T0150933

Praise for *Postcards to the Universe*

"Melisa Caprio magically inspires the reader to take a deeper look into what it is that we really want to manifest into their lives and helps them clear out any blocks that might be keeping them from achieving that. I love how she masterfully weaves thought-provoking text, inspiring stories, and soul-empowering activities all into one fantastic life-changing book. It's a complete guide to help you manifest your soul's desires and move your life forward!"

—G. Brian Benson, award-winning and #1 bestselling author of *Habits for Success—Inspired Ideas to Help You Soar*, coach, creative, TEDx speaker, and radio personality

"Manifest your soul mate, dream job, or anything you desire with Melisa Caprio's *Postcards to the Universe*! This beautiful page-turner will make you believe in magic! And possibly stay up late to create your very own postcard and rush it to the post office. That's what I did, and it changed my life!"

—Diana Silva, founder of Molé Mama, podcaster, radio show host, vlogger and author of *Molé Mama: A Memoir of Love, Cooking, and Loss*

"*Postcards to the Universe* is a visual jewel. With loving spirit and kindling fire, artist-photographer Melisa Caprio leads you on a lush journey through the art of manifesting your heart's desires. *Postcards to the Universe* helps you harness the power of the Universe and tap into your deepest creative source."

—Carolyn Flynn, award-winning author of novels, essays, and short stories, co-author of *The Complete Idiot's Guide to Creative Visualization*, TEDx speaker, book coach, and writing mentor at The Story Catalyst

"What I love about this book is the unique and fun way it can help you get what you want in life. And it illustrates that with wonderful stories of how others have used these simple, yet powerful, techniques to manifest their own desires. While I didn't create a postcard, as the author suggests, to get my dream Victorian house, I did lots of fanciful drawings of it, so I know these ideas work. Read this inspiring book and reap. It will show you not only how to manifest the house you might want but also such things as a career, a relationship, or the perfect job."

—Allen Klein, TEDx presenter and author of *Positive Thoughts for Troubling Times*

"Melisa Caprio has created a beautiful and wondrous global manifestation movement that is simple to follow, yet oh-so-profound. This book leads us straight into the heart of that life-affirming project, as we learn about Melisa's extraordinary personal story and the positive tales from people who have studied with her. Here's the real secret sauce of this book: we get to fill our bags with helpful tools and begin to road trip down our own manifestation highway! Step by step, Melisa guides us on a journey to create more love and joy, to nurture deeper relationships, and to realize our wildest dreams. This is an adventure you don't want to miss—I'm in! Can't wait to see your postcards, too! Wheeee!"

—Sherry Richert Belul, happiness coach and author of *Say it Now: 33 Ways to Say I Love You to the Most Important People in Your Life*

"Melisa Caprio's new book, *Postcards to the Universe*, is a wise, loving tribute to hope, compassion, beauty, courage and kindness. A poignant blend between photographic beauty and practical wisdom. It makes a persuasive argument in support of what is truly meaningful and worthwhile in our lives. Yes, Melisa we are all a work in progress and your book reminds us of the power and complexity in everyday experiences."

—Mirta Gómez del Valle, professor of art at Florida International University, photographer, and creator of seven published Monograph books

"Well organized, practical, and aesthetically pleasing, *Postcards to the Universe* is an invitation to access the best version of ourselves, and experientially reframe the way we view and interact with not only ourselves but life itself."

—Jamie Dawn, CSC, 12radio host, success coach, and author of *Evolutionary Revolutionary*®

"Melisa Caprio's *Postcards to the Universe* makes a galactic case for believing in the bigger YES surrounding us. Her solid divergence from the Glam-i-fest genre offers a refreshing perspective that compels participation and propels results. If ever there was a time to embrace her words of hope and inspiration, it would be now. *Postcards to the Universe* didn't just help me find my superpower, it became it."

—Mark Husson, founder and CEO of 12Entertainment Corp, host of 12Listen and 12Radio.com and author of *Lovescopes: What Astrology Knows about You and the Ones You Love*

"Have you read all the metaphysical books on manifestation but still struggle to create your dream? Then read one more book, Melisa Caprio's book *Postcards to the Universe*. But do not just read it, do the exercises and watch your world change. This book will help you clarify what you want and send this message to the Universe. Melisa Caprio's methods are powerful and transformational. Her writing is clear and inviting. Once I started reading I could only put it down to follow her advice. Read the book and you will believe that you can change your life. Do the exercises and you will change your life."

—Dr. Elisa Robyn, PhD in psychology and author of *The Way of the Well* and *Pirate Wisdom*

"'I completely let go of that dream, but it didn't let go of me.' ...As I read Melisa Caprio's *Postcards to the Universe*, that beautiful line really grabbed me. I knew I was about to learn new tools about my favorite subject—intentional, mindful manifestation—and I knew Melisa was sharing something powerful with us all. Manifestation is like breathing. We can't help but do it, and, most of the time, we are not aware of it. Through a series of stories from Melisa and others, some exercises that open doors to freedom, and some gorgeous pieces of visionary art, Melisa guides us to the awakening of our ideal lives. Her book is the guidebook on the journey from the dream that is too impossible to create to the life that is that dream. This book is a box full of excitement called *Postcards to the Universe*."

—Sam Beasley, author of *Your Life Is Your Prayer* and *Wealth and Well-Being Workbook*

"*Postcards to the Universe* is a beautiful tribute to the power of the mind. Melisa Caprio clearly captures the steps to manifesting that anyone can follow. This book is a primer for manifestors just getting started and a great refresher course for veteran manifestors. Using her passion for photography, Caprio takes manifesting to the next step with the physical postcards she teaches her reader to create. Powerful!"

—Kristi Brower, radio host and author of *Relationships for Spiritual People*

"*Postcards to the Universe* brings to the forefront a realistic approach to manifesting your dreams and soul's work. Throughout the book not only does she offer practical processes to bring you in alignment with your aspirations but she does so with examples of inspiration and proof. I truly recommend this to be on every nightstand and in every office to remind us that we can achieve our dreams...one focused postcard at a time."

—Angie Ates, CEO and founder of Academy EPIC, corporate trainer and keynote speaker, and author of *Manifest Your Best Year Yet*

Postcards to the Universe

Postcards to the Universe

HARNESS THE UNIVERSE'S POWER AND MANIFEST YOUR DREAMS

MELISA CAPRIO

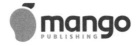

Coral Gables

Mango Publishing Group
2850 Douglas Road, 2nd Floor
Coral Gables, FL 33134 USA
info@mango.bz

Postcards to the Universe: Harness the Universe's Power and
Manifest Your Dreams

ISBN: (p) 978-1-64250-059-2 (e) 978-1-64250-060-8

LCCN: 2019944236

BISAC: OCC014000 BODY, MIND & SPIRIT / New Thought

This book is dedicated to my mother, who has always been my biggest supporter, and told me to never give up on my dreams. I love you, Mom.

I would also like to thank all the wonderful participants who created postcards and submitted their manifestation stories to me. This book wouldn't exist without you. You each are my inspiration.

Also, dedicated to Wayne Dyer, who has always been a huge influence in my life, and whom I had the pleasure of meeting a couple of years before he passed away. Below is his signature on a note where I wrote the words, Postcards to the Universe, when this book was still just a vision in my head.

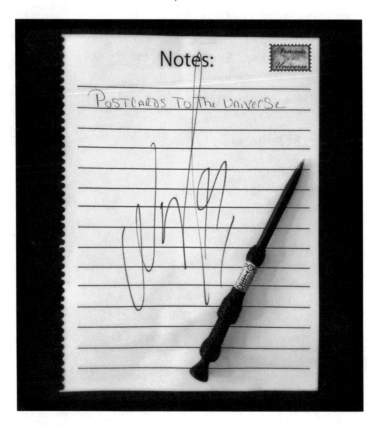

Table of Contents

Foreword

When the idea of *Postcards to the Universe* was born, I knew it was going to turn into a global movement. Melisa has discovered a new twist to manifesting: to be the creator of your reality and to direct your destiny, your vision and intention must seamlessly come together.

Very early on in this project, I would ask Melisa to come to my live classes and share her postcards with my students. I was teaching them how to use the zero-point field (the energy that surrounds us), by setting clear intentions, raising their emotional frequency, and running a movie of it all in their minds.

Adding in the postcard component was a way for them to enhance their creative visualization with her beautiful photography and send their cards out as an action for the intention to manifest.

Melisa has done an extraordinary job of combining art and manifestation, making it tangible and fun for us all to live our dreams.

Jennifer Grace
Hay House Author

A Note from the Author

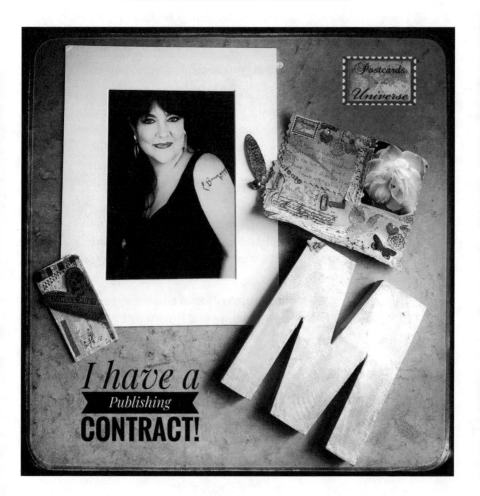

"I have a publishing contract, and my postcards to the universe book has been published. Thank you."

—Melisa

I thought I had a pretty good life: married, living in a small coastal town in a cute little house, and working my dream job. At the time, I photographed dolphins doing therapy with handicapped children. I did this for seven years. But within a thirty-day period, my job ended, my marriage fell apart, and I had to leave my beloved home. It was the most traumatic time of my life.

After years of sadness, loneliness, and confusion (during which I moved in with family), I received a divine message. In that sweet spot between sleep and wakefulness, I heard very clearly the first beckoning to create *Postcards to the Universe. Postcards to the Universe?* The words echoed in my mind. I had no idea what they meant, but intuitively felt they were important. I got out of bed, got online, and bought the domain name, knowing somehow this was something I had been called to do.

I created and founded Postcards to the Universe™ A Global Movement for Manifestation; I invite people from around the world to participate in this movement by using photography, art, personal wishes, and desires, and sending them out to the Universe via a postcard.

My inspiration comes from a desire to host forums where people come together in creative ways for global change. I see and feel a great need for growth, inner reflection, inspiration, and healing by combining art, photography, and manifestation.

I believe we inspire others through collaboration and co-creation. I offer workshops that are not just about photography and art, however—they are about transformation and manifestation. I guide and inspire participants to go within, and they experience huge shifts.

Through photography, I use the camera as a device to change old perspectives that no longer serve. Using the camera as a tool to shift our focus, I teach participants to

start seeing themselves in a new way—with a new lens, if you will.

In this book, I am featuring the postcards I received either from my workshops or from manifestors who have sent them to me. As you flip through the pages, you will also see each person's inspirational story.

This is my postcard. I created it a few years ago after attending a writer's workshop with one of my heroes, author Wayne Dyer. It hangs on my gallery wall, seeping into my consciousness on a regular basis. One of my dreams was to have my book published, and share my vision with the world. This book is witness to one of my greatest desires manifested into reality. This is the Law of Attraction in action.

I hope this book inspires you to go after your dreams; the Universe has your back and will meet you where you want to go. All you have to do is believe it! Of course, you can make a postcard and share your story too.

Introduction

"The law of attraction states that whatever you focus on, think about, read about, and talk about intensely, you're going to attract more of into your life."

—Jack Canfield

What Exactly IS Manifestation?

What is manifestation? Many people are throwing that word around. So, what does it mean, exactly? Manifestation is when something materializes into form by using the Law of Attraction—whether it's something physical that you wanted, all the way to new relationships, jobs, and life circumstances. It is the magnetic power of the Universe that draws similar energies together. It manifests through the power of creation, everywhere, and in every area of your life. This law attracts thoughts, ideas, people, situations, and circumstances, both good and bad. You cannot escape this law. When I first heard about it, I thought, *well that stinks. Now I have to take some responsibility for some of the terrible things that happened in my life.* And yes, we do. The good news about finding this out going forward is I have much more power in what happens in my life. I am not a victim to circumstances. I am co-creator with the Universe. I have a lot more control over what my life will look like moving forward than I realized.

I am going to share with you a personal story of how the Law of Attraction worked in my life and how something I deeply wanted to experience manifested. I had no idea about the Law of Attraction or manifestation at this point. It was only later, when I looked back, when I had learned about its properties, that I could see how it is always working in our lives.

When I was a little girl, I wanted to be a marine biologist. I was obsessed with Jacques Cousteau, and I would watch every nature special he produced. I especially wanted to study and work with dolphins. This childhood desire was so strong that I used to dream about being on the *Calypso*, Cousteau's boat, studying with him and his sons. But more than anything else, I wanted to work with dolphins. I loved the seals and whales as well, but it was the dolphins that spoke to my soul. At that time, I was still a very young girl

living in New Jersey. Time went on, and my family moved us to Florida. When I became a teenager, I took a marine biology course in high school. My teacher, a man, was not very supportive of women embracing their dreams and was very discouraging of a young girl becoming a marine biologist. I clearly got the message that it probably wasn't an option for me, and being an impressionable, insecure girl, I believed him. I took on that story. It was a subconscious response, but slowly as boys and fitting in with the in-crowd became more important, I let my dream of marine biology and working with dolphins die.

When I got to to college and was trying to figure out what I wanted to major in and make a career of, I decided on journalism, which never really resonated with me. I did it just to do something. Until one semester, when I took an elective class on photography—that was it—I was hooked. I changed my major to photography and fine art. It became a deep love affair.

I started a photo project where I followed my sister, who is developmentally disabled. I would photograph her and her friends in school and their programs, at group homes, and at the YMCA. It opened many new doors for me, and I was getting accolades for my sensitivity and unique perspective. Through my work photographing the disabled community, I graduated with a thesis in documentary photography. For years after, I did some traveling, worked in restaurants, opened a photography gallery and went on with my life as a photographer. I was still doing my documentary series on my sister and the community, but I was getting restless with the project, and was looking to see how I could take it further.

One day I was watching television, and I saw a story about disabled children doing therapy with dolphins in the Florida Keys. It was only eighty miles away from where I lived. I immediately wrote to the founder of Dolphin Human Therapy, Dr. Nathanson, who created the program. I actually

handwrote him a letter explaining what I did, and that I would love to come and observe, and maybe take some photographs for my project. Within two weeks, he wrote me back with details on whom to contact, asking me to make an appointment. A month later, I went for my first visit with my camera. The agreement I made was to provide copies of pictures to the parents who gave permission for me to observe and photograph the sessions. The families loved their photos, and the staff really took a liking to me. On my fourth or fifth visit, Dr. Nathanson who ran the program, asked to take me to lunch. He proceeded to tell me how much he loved my photos, and how happy the families were with them. I had a certain sensitivity to the subject having grown up with a special-needs sister. He wanted to know if I would be interested in becoming their staff photographer; he wanted to hire me full-time.

I said "yes" on the spot. Meanwhile, I lived eighty miles away, had a photography gallery, a restaurant job, and was living with someone. I hadn't figured out how I was going to do it, but I was doing it. For the next seven years, that was my job. Every day I got to work with dolphins. I absolutely loved every second of it. So, you see how the Law of Attraction and manifestation works? I had a strong desire as a child to work with dolphins, but life took over, and my career went in another direction. The Universe doesn't worry about that. That dream becoming a reality was already in the works. It came to me in a completely different way than I ever could have imagined. Even though I didn't become a marine biologist, it still manifested through my work as a photographer. I never could have imagined that would happen. I completely let go of that dream, but it didn't let go of me.

This is a perfect example of how this law works. I want you to look back into your life. Can you see a similar situation where you unknowingly manifested something you wanted? I know if you look deep enough, you will find

it. There are also things in our lives that we manifest that we don't want. Look at those too. Whatever we focus and put our energy into is what we manifest. This also means we bring into our lives the things we don't want. If we keep worrying, going over the worst-case scenario in our minds, and putting our energy into something unwanted, what we are doing is becoming a magnet for that unwanted outcome. I have learned to shift that energy, and place my focus on what I do want. That is why I created this project.

Postcards to the Universe was birthed from learning about being a conscious co-creator with the Universe for what we want and learning to stop focusing on what we don't. This is very important—you must believe that you deserve to have what you want; you must have faith that the Universe has your back and is delivering the fulfillment of your wishes to you. Allow it to unfold as it is meant to, get out of the way, and let it go!

One of the biggest reasons that we encounter so much resistance to getting what we want is because we have a deep fear that we don't deserve it. We must be a match energetically to what we want. If I want a brand-new shiny car, and am working on manifesting it in my life, yet I don't feel I deserve it or cannot picture myself driving and owning that car, guess what is going to happen? Nothing. I am not a match energetically for that car; I am resisting its coming to me. If you have feelings that you are unworthy and undeserving of having your dreams come true, then I recommend you find a way to fix that. Fix it as soon as possible. Work with a therapist or a coach; find a class or program that will teach you to love yourself, so you know you deserve everything you want. This shift in thinking will completely change how you manifest what you want. The second thing I want to say is that everything is subject to divine timing. Have faith that a positive outcome is unfolding, because the Universe wants to give you everything you want! The problem is that we get very

impatient, and butt in with how we think it should show up. Know that it is working out the way it is meant to, and move on with your life.

After I left my job as the staff photographer working with the dolphins and children, I struggled for a long while not knowing what I wanted to do. At that same time, my marriage ended, and I moved back to my old hometown. It was a difficult time, to say the least, and I hadn't heard about the Law of Attraction yet. As I started doing internal work and healing, I learned that we co-create with the Universe. This is when I really took a moment and looked back over my life to see how I helped attract everything that entered it. I had to take responsibility for both the good and the bad. The more work I did, the more I connected with others who helped me reach the next level in my learning, and that is how *Postcards to the Universe* was born. I believe it was divinely gifted to me. I heard the words whispered in my ear, "Postcards to the Universe," very clearly one night, and felt the significance of those words; inspiration sparked, and a movement was born. I make my own postcards on a regular basis when I want something; it is very powerful.

When I looked back over my life's history closely with a fine-tooth comb, I found evidence everywhere that we in fact do attract people, situations, and experiences to our lives. Remember my story of wanting to be with dolphins? I thought I had to be a marine biologist, but I went into photography instead, so I let my intention to study marine biology go. The Universe created the perfect circumstances for me to have the experience of working with dolphins, and I wouldn't change the way it happened to me for anything in the world. It was a magical experience, and the personal fulfillment I received from getting to know those dolphins, plus the added bonus of working with amazing special-needs children, are some of the greatest blessings in my life. I have written another book on that magical

experience, filled with touching photos, and one day, I'll publish that book too.

You are constantly co-creating in your life. Isn't that wonderful? Take the time to reflect and ask yourself what it is that you want. Is there an area in your life where something is missing? Even those of us who are abundantly blessed desire more. I know I do. Many of my dreams have already manifested, this book is one, yet there is still more that I want to create.

I started *Postcards to the Universe* to share with others a fun way to tap into the energy of childlike creativity. Children are such master manifestors! Their imaginations are so vivid, they innately know the feeling of already having what they want. Their dreams are realized the way a meal is delivered to the table when it is ordered from a restaurant. I wanted to use art and photography in the process of making these postcards as a creative means to reach into that same kind of magical childlike energy. Participants really get into the fun of it. It's like being a little kid again, and the Universe responds to that energy very strongly. We just set a very powerful intention out there. The Universe says, "Okay, got it, babe! I am on it."

I hope as you go through the book that you enjoy seeing other people's postcards, and reading their personal stories of manifestation. Every postcard and story in this book was sent to me with their creator's permission to photograph and include them; they get to be a part of this creative journey. We are all co-creators, and together, we have the power to shift our world—starting with ourselves—and radiating outward to everyone else whose lives we touch. I have a big vision for my life and this world. Many of the participants in my book feel the same way. Remember, our inner world gets pushed outward into reality. Together we each are doing our part. Enjoy the magic!

"The biggest adventure you can ever take
is to live the life of your dreams."

—Oprah Winfrey

"One is loved because one is loved. No reason is needed for loving."

~ Paulo Coelho, The Alchemist

Part One

Love and Relationships

"Ask for what you want and be prepared to get it."

—Maya Angelou

How Do We Cultivate Loving and Harmonious Relationships?

We all want harmonious relationships. In every area of our lives, we would like to have healthy relationships— with our parents, siblings, friends, coworkers, employers, employees, and of course, with our romantic partners. I can almost guarantee everyone reading this book is in or has had a difficult relationship of some sort. So, how do we cultivate harmonious relationships? Relationships are perfect mirrors for what is going on inside our own hearts. Imagine you are being triggered by your mother, because she constantly criticizes you. She believes she does it out of love for you, but every time you are together, you notice your heart beats faster and your stomach churns— because you are waiting for her next judgement. When it comes, it sends you reeling. The reason you are having this experience and feeling this is because inside you believe you are not good enough, and your mother is reflecting that back to you.

This gives you a perfect opportunity to heal your limiting and harmful beliefs. Once you heal, your relationship with your mother will shift—without even having to confront her about how much it bothers you when she makes her comments. She will most likely stop criticizing you, because she is responding to your new energy, and if she continues to nag you, it won't trigger you any longer, because her criticisms hold no more power over you.

If you reflect on your relationships, can you identify the ones that are or were triggering? (This is very different from being in an abusive relationship. If you are being abused in any relationship, the first thing you need to do is remove yourself, get to safety, and get the help and support you need.)

We are in relationships with everything and everyone around us. Desiring harmonious and loving relationships is

a common desire that we all share. We want to enjoy being with the people we love, and we want them to enjoy being with us. If you are around someone who makes you anxious and nervous and irritates you, take a moment to examine that. How does that irritation affect you? What emotions does it bring up? Where in your body are you holding it? This is very important, because it presents an opportunity to locate the wounds in ourselves; the best way to build healthy relationships is to heal what is unhealthy inside of us. Once we begin the healing process, our relationships shift and change. Some people might even step back from their relationship with you, because you don't match energetically any longer. With those, you'll learn to keep a respectful distance, and you will wish each other well, but won't be quite as close. Then there will be those who shift to a higher vibration along with you. Your growth will be the catalyst for their own consecutive growth. New people will enter your life who better match you energetically to replace those who step away. Remember, everything vibrates energetically, and we magnetically draw that which matches what we radiate.

On our journey through life, as we discover more about ourselves, we all have wounds that we carry. The best advice I can give anyone is do whatever you have to do to heal those wounds. The more you love yourself, the better your relationships, in general, will be. The more secure you are with who you are, the less you will be triggered by what others say and do. A very common self-limiting belief many of us have is, *I am not good enough* or *I am not worthy.* Everything stems from this self-negation. If you carry this story around with you, it will manifest in your life, especially in relationships. Your relationships will reinforce your belief that you are not good enough. You aren't worthy of having a healthy, loving, romantic relationship. I have been there myself. Of course, I didn't realize it when I was experiencing it. Later, much later, after doing the inner work and getting help from programs

and coaching, I shifted the dynamic. Learning to be with yourself and loving your own company has tremendous rewards. You get to really know yourself—inside and out. You know what you will no longer tolerate in relationships. It is very empowering. Many people jump from one unhealthy relationship to another unhealthy relationship, because they cannot be alone or enjoy their own company. One of the greatest gifts you can give yourself is to love yourself and honor and enjoy who you are.

When you are ready, the next romantic relationship you manifest will be healthy and have qualities you have been desiring. The Universe wants to give you what you want. The problem is we send mixed messages, we say we want a respectful loving relationship, yet we allow others to disrespect us. Do you see the problem with that? We must be very clear with our thoughts, emotions, and actions, so the Universe knows how to give us the relationships we want.

You know you have blocks in manifesting healthy, empowering relationships. You recognize that, and now, you want to know what to do. Well, good news! The first step is to realize that you have these blocks and self-limiting beliefs. The second step is to start doing research into how to lift any blocks and limits you have imposed upon yourself. We have a wonderful tool at our fingertips that we can use—the internet. Another one of my favorite resources is the self-help section at the bookstore. Start there, and connect with people who have done the work themselves and can help you. Take classes that help you heal. Hire an expert, a therapist, or coach to guide you. Go to a healer for help. There are so many things you can do—join support groups or start a support group. You don't have to figure it all out on your own. Let go of that belief that you cannot afford it or that it isn't available to you. That is just another limiting belief. Declare you are getting yourself support,

and I promise you, the Universe will bring you what you need to get that support.

What if you have decided you want to manifest healthier relationships, but you're a total people pleaser? You completely put yourself last so you can take care of everyone else. People cross boundaries with you all the time. You feel stressed out, exhausted, and grow more resentful the longer you try to make other people happy. Part of you wants to say no when you're asked for one more thing, but another part of you is screaming louder that you cannot say no. You want everyone to like you, so you must say yes. The more you say yes to others when you don't really want to do something, the more aggravated you get. The angrier you become, the more anxious you grow. What starts to show up in your reality are even more needy people wanting more from you. You think, *I cannot take this one more second!* You are at your wits' end; you are exhausted, and you start to break down. You may even get sick. Being a people pleaser is not a high vibrating energy. What it is, is a desperate needy feeling inside to be liked and valued. But you are not honoring yourself when you are a people pleaser. What you do is bring more needy people in your life that need to be pleased. These are not healthy relationships, and when neither of you have boundaries in place, resentment and toxicity occur. The message we are sending to the Universe is not, "send me healthier relationships," but, "send me some more needy people I can try to get my validation from." Do you see that? Good.

So, let us do an exercise to release yourself from this trap. It is a very simple exercise that can do without a lot of effort, but it does require giving yourself the permission to do it. Set aside some time for yourself to do this exercise, you will need a journal and a quiet place. Sit down, take a few deep breaths, and set your intention that you are going to release your attachments to relationships that no longer serve you and are causing you any kind of anxiety. On paper, you are

going to write down everything you no longer want to show up in your reality in terms of relationships. List everything that comes to mind. It could be bickering with your partner, feeling disrespected at work, being taken advantage of by your friends or family. Be specific in what you write down—even little things that may seem insignificant. Write it down. When you are finished, take that sheet of paper and put a big X across it. You are crossing it out. Say to yourself out loud, "I am no longer a match for these kinds of relationship issues to show up in my life."

On another sheet of paper, write down your answers to this list of questions you can use to help clarify what you want your relationships to look like.

1. What do you believe you deserve in your life and in your relationships?

2. Do you trust yourself to take care of your needs? How would you do that?

3. What do you need to let go of in your life? How do you think you will feel once you let it go?

4. When was the last time you didn't get something you wanted in a relationship, but it worked out for the best?

5. What would your ideal relationships look like to you, if nothing stood in the way?

6. What does "love" mean to you? How do you show love to yourself and others?

7. What would your daily life look like in your ideal relationships?

8. Have you ever valued someone else's opinion over your own? Why? How would that situation have been different if you put yourself first?

9. What do you bring to relationships? Are you happy with what you bring to the table?

10. What does "forgiveness" mean to you? What do you need to forgive yourself for? How can you love yourself as you go through the process of forgiving?

11. Do you need to forgive others? How would your life be different if you forgave those people who hurt you?

12. What do you think about yourself when you look in the mirror?

13. What do you love about your life right now? Why do you love it?

14. What do you love about your relationships right now? Why do you love them?

15. Is putting yourself first a negative thing or a positive thing? What if you believed that being focused on your feelings could be beneficial to your well-being? How would your life change?

Take some time with this exercise. Really think about each question, and look over what you wrote down. This is a great way to see where you are at and where you stand in your relationships. It's a clarity exercise. Sometimes we think we know what we want and don't want, but it isn't until we see it written down that we realize where we are emotionally.

After you get very clear on what you will no longer accept in your relationships, and can see where you are emotionally, write a love letter. The love letter can go into your Love Box. Later on, I'll explain more about the Love Box and how you can create one to help enhance your present relationships or to manifest new ones. The love letter you write could be to a partner–whether you are in an existing relationship or wish to start a new one. If you want to focus on a more harmonious relationship, it could be to a family member. You could write to a friend or coworker with whom your relationship is struggling, and you want to heal the rift between you. It works for anyone you choose.

Keep the love letter in the box until you manifest that relationship. Then, take the letter from your box, thank it for helping bring in your manifestation, and release it and let it go. It is done. You could do a letting-go ritual. For example, you could burn the letter, or you might save it, and tuck it away in your journal. This is totally up to you; it's a personal choice. There is no wrong way to do this. I like to do this exercise on a new or full moon. I believe I am working with the power of the moon to help enhance my manifestation. The reason I say there is no wrong way to do this, is because the Universe is responding to you and your energy. If your energy is strong, and you clear these blocks to receiving, and you believe that you deserve to have what you are asking for, then, have faith. It is on its way to you!

The love letter for your Love Box is one way to help attract a relationship. But I always tell people to create a separate postcard specially, with unique images to help manifest a new relationship or to shift the energy in an existing one. The love letter is more specific in that you are writing to a loved one and specifying attributes you want to share with a specific person. The postcard is more general, a visual snapshot to show the Universe what you want. It allows the Universe to do its job as it intends without your specifications getting in the way. Many times the Universe has more in store for us then we could ever realize.

When you make a postcard, you are placing your energy into it. When you sit down and get into your creative space, all sorts of magic begins to happen. Imagine you are a casting a spell, and you place all your ingredients into a potion so that it has all it needs to do your bidding. That is what creating a manifesting postcard is like. The more you put into it, the more you infuse it with your own unique magic. When you send it out and release it, you affirm your declaration, and so it is! Now, get out of the way, allow the Universe to bring it to you, and know that it is coming. The how, why, when, and what it looks like are none of your

business. I know that sounds counterintuitive, but trust me. The Universe knows way better than you what you need. The Universe loves you and it wants you to be happy, so trust that what you need is on its way!

Love and Relationships—Tips and Techniques

The Love Box

Here is what you need to create a Love Box to help you manifest the kind of relationship you want to bring into your life. It can be a romance Love Box, a sibling Love Box, a parent Love Box, child, friendship—whatever it is you desire. The only difference is what you put in it, and where you place your box.

Find a box—it might be an old jewelry box, an antique box, a cigar box, anything you can close that resonates with you. I happen to love wood cigar boxes. I am not sure why, but I have always just loved the way they feel, look, and smell, even though I don't smoke cigars. So, when I create a Love Box, I use old wood cigar boxes. Here is what you will need.

▶ Your special box—whatever speaks to you.

▶ A love letter written as if your desired relationship already exists in the physical, present moment. If it's romantic, write it to your partner. If it's for a family member, write as if you already have the relationship you desire. For example, *To my partner, I love you because...* or *I love that we...* Imagine that you are already living your ideal relationship. What would you say to your partner, or mother, family member, or friend? Remember to express gratitude for what you have already created in your imagination. In your love letter, write it as if it's already manifested. *Mom, I am so grateful that you and I are...* It is very important that you write as if it is already in the here and now!

▶ Take the time to find a piece of beautiful paper, your favorite pen, and handwrite your love letter. Don't just write it on yellow legal pad. Show the Universe that you are serious in your intent, and

want to create something special and magical. This is a powerful manifesting tool. When you take the time to handwrite your desire, you are infusing that paper with your energy, and the Universe only responds to the energy you put forth. After you write your letter, roll it up and tie it with a piece of beautiful twine or your favorite color ribbon.

▶ Include a small mirror in your box. Mirrors are for magnetizing, and putting a mirror *face up* under whatever else you include in your box, helps magnetize your desire. If you want to get rid of something, let go of, distance yourself, or repel something away from you—put the mirror *face down*. This is an important distinction.

▶ Find an image that matches what you want to manifest. If it's a romantic relationship, print out photos that correspond with what you envision for the relationship. The same goes for other kinds of relationships. It could be picture of a lovely couple kissing or at their wedding if that is what you want. It could be a picture of sisters lovingly holding hands, if you are manifesting an intimate sibling relationship. Be specific. If you want to bring a romantic relationship to your life, find a photo of a person that fits that physical description and include that. The Universe will know your taste or style from the images you select. You can cut out pictures from magazines, or find them on Google or Pinterest. I love Pinterest to help me find images that resonate with me. I created a whole vision board using Pinterest. Remember, these images are only a guideline; be open to what the Universe has for you. It is usually bigger and better than you can imagine.

▶ Place things in your box that fit your desire. If its romance, and you want to be married, put in a costume engagement ring. Include dried flowers, a rose quartz shaped as a heart, images of where you will honeymoon, etc.—whatever it is you want to bring into your life. If it's a harmonious family relationship with a specific family member, place images that represent the person. Include a white feather or white candle. White represents peace. You can sketch or draw images yourself, or you can find ones that look like the kind of relationship you wish for. Get creative and use your imagination.

▶ If it's self-love you want to manifest, find things that are unique and magical to you and put them in your box. Take self-portraits that you love, write a love letter to yourself. Put in your gratitude list of what you really dig about yourself. Place a green candle in your box. Green is a healing color and resonates with Mother Earth, where we all come from.

▶ After you have filled your box, place it somewhere you can see it every day. It will seep into your subconscious, and you will find the Universe conspires to bring you what you most desire.

▶ According to the practice of *feng shui*, where you place your Love Box is important. Your home is laid out as a square, filled with nine boxes. Each room can be similarly compartmentalized. The energy is the strongest in certain areas of your home, so you should place your Love Box in these areas.

▶ Since romantic energy is strongest in the bedroom, according to *feng shui*, place your romance Love Box in the far-right corner of your

bedroom. From the door, peer in; the far-right corner is your romance corner. You can include a red candle somewhere in that corner for passion or pink for love.

▶ The center left when you first walk into your home or a specific room is where you place your Love Box for your family; that is where the familial energy is the strongest.

▶ The top left corner of your home or that same corner in a designated room is where you should place the Love Box you created for yourself. Remember self-worth is the most important thing you must create; everything comes from believing you deserve it.

Your Love Box is private, and you should be able to keep it sequestered from prying eyes if you choose. I prefer to use a box with a lid that shuts. The last thing you need is for a friend or family member to critique the contents of your special Love Box. Sometimes, people with the best intentions can contaminate what we are trying to manifest with their own projections and energy. You don't want that for your Love Box. Only invite those you trust to come near it. This box is special and magical, and should only have your love, and the support and love of others energizing it. Happy creating!

Below find the Feng Shui Bagua of your home which will help guide you in placing your box.

WEALTH, PROSPERITY AND SELF-WORTH	FAME, REPUTATION & SOCIAL LIFE	MARRIAGE, RELATIONSHIPS AND PARTNERSHIPS
ELEMENT: WOOD	ELEMENT: FIRE	ELEMENT: EARTH
NUMBER: 4	NUMBER: 9	NUMBER: 2
LATE SPRING	EARLY SUMMER	LATE SUMMER
COLORS: PURPLE, GREEN, GOLD	COLORS: RED	COLORS: PINK, SKIN TONES, EARTH TONES
HEALTH, FAMILY AND COMMUNITY	**GOOD FORTUNE CENTER**	**CHILDREN, CREATIVITY & ENTERTAINMENT**
ELEMENT: WOOD	ELEMENT: EARTH	ELEMENT: METAL
NUMBER: 3	NUMBER: 5	NUMBER: 7
EARLY SPRING	COLORS: YELLOW, EARTH TONES	EARLY FALL
COLORS: PURPLE, GREEN, GOLD		COLORS: WHITE, BRIGHT AND PASTEL COLORS
WISDOM, SELF-KNOWLEDGE AND REST	**CAREER, LIFE MISSION & INDIVIDUALITY**	**HELPFUL PEOPLE, SPIRITUAL LIFE & TRAVEL**
ELEMENT: EARTH	ELEMENT: WATER	ELEMENT: METAL
NUMBER: 8	NUMBER: 1	NUMBER: 6
LATE WINTER,	EARLY WINTER	LATE FALL,
COLORS: BLUE-GREEN	COLORS: DARK BLUE, BLACK	COLORS: GRAY, MAUVE

Front Entrance

"Eat healthily, sleep we
breathe deeply,
move harmoniously."

~ Jean-Pierre Barral

Part Two

Health

"When you visualize, then you materialize. If you've been there in the mind, you'll go there in the body."

—Dr. Denis Waitley

How Can We Live in Optimal Health, and How Does That Set the Stage for More Manifestation?

One of the most important parts of our lives that we want to flow smoothly is our state of health. No one wants to be sick. Being ill is the biggest blockage that stops us from living the life we want. Does that mean that we manifested our diseases? That is a very scary question to ask ourselves. No one plans on being sick; no one wants to think they've brought disease on themselves. So, I want to say this first, and it is really important to state. Never, ever blame yourself and think you caused your illness. That isn't how it works. How it does work is, if we are feeling a dis-ease somewhere in our lives, our bodies *can* take on that energy and disease *can* manifest, but of course that isn't always the case. Our bodies are part of our great energetic system and are a wonderful beacon that sends signals if something is off emotionally in our lives.

In Louise Hay's book, *You Can Heal Your Life*, she describes different diseases and where they manifest in the body to show how emotional energy correlates with disease. I highly recommend reading that book. It is fascinating to see how emotional trauma is stored in our bodies—and even more interesting—where the emotions show up as pathology. For example, many women who have developed breast cancer have trauma surrounding motherhood, whether it with their own mothers or with themselves as mothers. Louise has been a tremendous influence in my life and spiritual journey, and I have followed many of her healing exercises to help me heal my own trauma. One of her most powerful exercises is mirror work. Mirror work involves sitting in front of a mirror. She recommends doing this first thing in the morning, before we get ourselves all dolled up, so we can see how we naturally look, without any masks. You then lovingly look into your own eyes, and tell yourself how much you love yourself. Let me tell you, this

is very hard at first, but the more you do it, the easier it gets, and something wonderful begins to happen. You begin to believe it, and your body responds in kind. I did this every day for thirty days straight, and I started to notice that I became much kinder to myself whenever I walked past a mirror.

I wrote down about ten affirmations, and each morning, I sat with my coffee in front of my mirror. I had no makeup on, and was still dressed in my pajamas and robe. At first, the only thing I could do was notice all my flaws: I noticed if my eyes were puffy; I criticized my hair and my skin; I scowled if my face looked bloated. I couldn't help but see every new line that showed up on my face. It was terrible, and I thought, *I don't want to do this, it's awful.* However, I made a commitment to myself, following Louise Hay's advice, to stick with it, and I did. Something started to shift after about a week. I wasn't noticing my flaws as much. I started to feel more compassion for my body, and I started to feel more grateful for how amazing my body is. If you think about the perfection of what your body is, and how it functions, it is truly mind-blowing. The fact that our bodies do what they do, to get us through our days, shows how incredible they are. When we criticize ourselves incessantly, our bodies respond to that. Imagine...you have thousands of thoughts going through your brain every day... and if many of them are caustic and self-critical?

Take a minute right now, and think about what you say to yourself when you look in the mirror or see a picture of yourself. I can hear you right now as I am writing this down. You may be saying: I look terrible; I am too fat; I am too skinny; my skin looks horrible; I hate my legs; I look old or tired or like crap. The list of self-insults is endless, and we say these abusive things to our bodies constantly. I still catch myself doing it, but now I consciously remind myself to stop as soon as I have negative thoughts, and I replace them with kind or loving words. I'm not always successful,

but I am getting much better. Imagine for a moment what kind of impact constant hyper-critical self-loathing has on our physical well-being. Do you think this makes our bodies want to perform at optimal capacity? Do you think our bodies respond with health when we trash them every day? I can guarantee you the answer is *no*. That is not what our bodies do. Our bodies believe us, and they start to break down.

Imagine that you spoke to your child or someone you really love the way you talk to yourself and to your body every day—a hundred times a day. What do you think would happen to that person? They would react as though they had been traumatized. But we have no filter about saying these horrible things to ourselves on a daily basis, and then we get angry when our bodies respond to the abuse we heap on ourselves.

According to the science project, "Talking to Plants" at Education.com, a study was conducted with school-aged children, showing the difference in plant growth relating to how we speak to them. Many schools have also adopted this experiment to show the effects of bullying. Even the corporation Ikea contributed its own informal study using plants. What happens is two exact plants are placed next to each other in the same environment, given the same amount of light, food, and water. One plant is praised and sent loving messages, and the other plant is insulted, called names and spoken to in anger. In the period of a month, the plant that is sent love is thriving, while the plant that is sent hate is wilting. Isn't that amazing? This just confirms to me how we all respond to energy. So, imagine how your own body responds. Our bodies wilt away. Our bodies suffer. We need to shift this immediately.

These studies have been confirmed in similar experiments on water. Dr. Masaru Emoto, a Japanese doctor of alternative medicine, conducted a study on human consciousness using the molecular structure of water.

His studies concluded that water would react to positive thoughts and words, and that polluted water could be cleaned through sending positive energy and prayer. In Dr. Emoto's landmark book, *The Hidden Message in Water,* both the positive impact of kind words, and the damage caused by negative words are evident in photographic images of frozen water crystals viewed through a microscope. Certain samples were spoken to lovingly, and had positive words written on them, while others had the opposite. They were written on with hateful words, and spoken to negatively. His photographs document that the samples of water which were spoken to positively formed beautiful, brilliant snowflake patterns that were colorful and complex. Yet, the water samples exposed to negative thoughts and words were asymmetrical and incomplete in pattern and lacking the vibrant color seen in the other sample treated with loving kindness.

I found that so profound and fascinating that I made a conscious choice to infuse my water with loving thoughts. Drinking water daily is one of the most important healthy things we can do for ourselves. If you don't do anything else to shift your health, please do these two things: drink more water, and speak to yourself lovingly. I drink filtered water in glass. I don't like to drink water from plastic, if I can avoid it, to prevent any chemicals in the plastic from seeping into my drinking water.

A great way to infuse your water or, really, anything that you drink, is to use coasters that have positive messages on them. I bought coasters that say, *Live, Laugh, Love.* I place everything I drink on them. You can also make your own. I have done this: Print out the affirmations that you want onto paper; cut them to the coaster size that suits your needs, and tape each on with a waterproof adhesive. Everything you drink will be steeped in positive and loving words. Our bodies are mostly made of water, and you will resonate with positive energy you drink in. You

could have a pitcher, on which you write positive words or affirmations, and use that to house your drinking water. This is a simple way to help add love into your body on a regular basis.

Blessing the food you eat is another amazing way to honor your body. Each time you have a plate of food in front of you, take a moment to silently bless that food you will be eating. Thank the fruits, plants, and animals that you are about to consume for offering you their gifts of nourishment. Thank the grains and nuts and seeds. I even thank the junk food I sometimes consume. I try not to make it a habit to consume junk food, but I am human, so it happens. I don't have to tell you that if you want a healthy body, consuming food that isn't good for you will not support that. But when you thank your food, you are energetically extending a feeling of gratitude that will help support your health. Your body will respond to this.

The more you focus your energy on having a healthy body, and the more you take action to support a healthy lifestyle, the more you will manifest good health in your life. Our thoughts on our health help create our reality on a physical level. The body is designed to heal itself, but we must believe that is possible. If you are struggling with your health, despite your best efforts to take care of yourself as you should, for example, you are eating right, exercising, taking your supplements, getting plenty of rest, but don't believe your body can heal—your cells are going to respond to your beliefs. Look inside to see what your beliefs are about the mind-body connection. Seek out information about healing yourself , especially if you've been resistant to try new therapies or treatments. When it comes to health and our healthcare, it's important to keep your mind and eyes open to changes in the medical paradigm, because science is advancing rapidly, and many antiquated practices have been replaced.

I believe very strongly in my own intuition; I follow it, especially when it comes to my health. I believe that doing some research on alternative healing modalities, along with a regular medical protocol can be beneficial to your overall health. I would never tell anyone to drop their doctors—that would be completely irresponsible of me. However, I do suggest also looking outside the box a bit for deeper meanings and answers that include alternative medicine. Trust your intuition.

Along with the mirror work, infusing our water, and blessing our food, I have a little ritual to share that you can do every day to help you learn to love and bless your body. It is so easy; it is something we do naturally every day, so I thought, why not include this ritual into our daily lives? I call it the Shower Me with Blessings ritual.

Health—Tips and Techniques

Shower Me with Blessings

The Shower Me with Blessings ritual is a daily practice
for a healthy body and mind. Each day we take the time to
shower and cleanse ourselves. I started doing this when I
was learning to better love and appreciate my body, and get
out of the habit of constantly criticizing myself. It was easy
to add this to my daily routine, as it takes no extra time. I
take a shower each day anyway, so, it was a simple ritual
to add on. You can even do a quick version while you are
brushing your teeth.

You don't need to prepare anything for this ritual. When
you step into the shower, instead of thinking about the
million and one things you usually think about, or going
over everything you need to do, and listing all your worries,
systematically send love and gratitude to each body part as
you wash it. Check in with your body and begin:

- Start with your hair. When you wash it, begin
 expressing gratitude to your body by saying,
 "Thank you, hair, for being vibrant, shiny, and
 luxurious. Thank you, brain, for your intelligence,
 creativity, knowledge, ability to reason, and for
 storing my memories. Thank you, consciousness,
 for my dreams and my connectedness to spirit."

- Move onto your face and neck. You will say,
 "Thank you, face, for presenting your beauty to
 the world. Thank you, eyes, for giving me sight.
 Thank you, nose, for allowing me to smell all
 of Mother Nature's gifts. Thank you, mouth, for
 speaking kindly to others, and for offering my
 smile to the world. Thank you, tongue, for tasting
 the blessings of food. Thank you, skin, for being
 a witness to how I show up to others. Thank you,
 neck, for the graceful way you hold up my head,

so I can move through this world. Thank you,
throat, for giving me a voice."

▶ As you move to your chest, arms, and shoulders.
Speak these words, "Thank you, chest, for housing
my heart and lungs, which allow me to live and
breathe freely. Thank you, blood, that flows with
life source throughout my body. Thank you,
breasts, for nurturing and nourishing new life.
Thank you, rib cage, for protecting these precious
organs. Thank you, shoulders, for holding me
up. Thank you, arms, for your ability to embrace
others. Thank you, hands and fingers, for giving
me the ability to touch my loved ones and my
ability to create."

▶ Next, you will move to your torso, back, and
sexual organs. "Thank you, stomach, for digesting
sustaining food and giving me nourishment. Plus,
thank you for supporting me by giving me my
intuition. Thank you, back, for your ability to hold
my body together and support me, so I can move
in my life. Thank you, kidneys, for doing your
job by flushing out my system. Thank you, liver,
for cleansing my body. Thank you, intestines,
for eliminating any waste that holds me down.
Thank you, ovaries, uterus, and cervix (or male
organs) for creating and birthing new life and
creativity. Thank you, vagina (or penis) for sexual
pleasure, connectedness to others, and bringing
new life to the planet. Thank you, booty, for being
so damn plump and cute, and my cushion when
I sit."

▶ Now move down to your hips, legs, knees, feet,
and toes. "Thank you, hips, for your flexibility and
helping me move my body. Thank you, legs, for
transporting me from one place to another with
ease, and for walking me through the blessings of

Earth. Thank you, knees, for your ability to allow me to bend and kneel in reverence. Thank you, feet and toes, for helping me follow your direction wherever you want to lead me."

I created this as an easy script to follow as you wash your body in the shower, part by part. You can follow mine, or add to it, but you can also create your own script. It may look a bit long, and may feel awkward initially, but the more you practice the ritual, the more natural it will become. Before I established this ritual into my daily routine, I used to spend my time in the shower thinking of everything I had to do. Now, I have completely shifted my experience when I wash up, and I believe my body loves the attention. She is craving these loving words. I believe the more often we do this exercise, the more our body responds to our loving blessings, and will want to be healthier for us. I am like you—a work in progress and always growing. I need to remind myself to keep up with my loving rituals. If you could even start out doing this once a week, that would be fantastic. I guarantee, your body will want you to do it more and more.

"Abundance is not something
we aquire.
It is something we tune into."
~ Wayne Dyer

Part Three

Wealth and Abundance

"Speak what you seek until you see what you've said."

—Anonymous

How Can We Live in An Abundant Universe with Limitless Resources?

Here is what happens—we want something; we think about it, and we may even daydream about it, but then we say, "Oh, I could never have that or do that." The Universe heard your original desire, but then it heard you just cancel that order. So, what do you think happened? It doesn't come to you, because your underlining belief is that what you want is impossible for you to achieve. The Universe is giving you exactly what you are declaring. We want to change this. We want to learn how to shift our beliefs, so that when we do want to manifest something, we know that it is coming.

How do we do that? First, we need to be very, very clear about what it is we desire. Sometimes, we think we want something, when what we really want is not the thing itself, but the feeling associated to that thing. Let me give you an example. You want a new home. Your family is growing, and your current home is bursting at the seams. You want more space, a backyard, and great schools for your children. You want your own bathroom that you don't have to share with your whole family. You would like your bedroom to be a private sanctuary, removed from the rest of the activity of the house. You want to walk through your house, and have it feel like your home: open, spacious, and inviting. What you are currently feeling is cramped, and what you want to feel is breathing room. What you want to feel is that your home is your sanctuary. What does a sanctuary feel like? It feels like a haven, a refuge, your own little oasis. It is your safe harbor. You have asked for it, so now what? The Universe heard you, and when your desire is strong enough, you keep going back to it and focusing on it, things start to present themselves to you in your physical reality.

A decision has been made. You and your family start taking action to help make that happen. You list your current house on the market, because you just *happened* to run

into that woman who is the realtor that you haven't seen in a while. You think, *what a coincidence, we just decided to sell our house.* No, that is not a coincidence. That is the Universe bringing you the opportunity to get to where you want to go. You list your house, and you start looking for your new home. Many possibilities come across your path, because your consciousness is focused on that new home. One gorgeous home stands out, and you think, *oh my goodness, this is gorgeous, and it checks all our boxes.* You and your family now have a decision to make—whether to buy this home or not. When you sit down and go over your finances, you come to find out that, *yes,* you can do it, but it will stretch the family finances significantly. So, to be able to buy this home, which has everything else you want, either you or your spouse will have to work longer hours each week or take a second job. You try to become creative with how you can make the numbers work. What you will start to notice is that you are now feeling stressed. You are getting so desperate, because you really love this house, and want it, and you are imagining all the different ways you and your family could make it work.

You decide you will take on extra hours each week to bring in more money. Great! The decision has been made, so you should be feeling very happy, because it is happening. However, you aren't feeling happy; you are feeling very anxious, because you are seeing how living in this new home now means less time with your family every day. How are you going to get the kids to school in the morning if you have to get to work earlier? You realize you will miss many dinners with your spouse and your children. Vacations will no longer be an option, because your family finances will be stretched too thin. You may even have to work weekends, and weekends are your family's thing. You all loved having the weekends to be with one another, to connect, and do fun, family activities. Your family enjoys taking mini-vacations on weekends quite a bit. That isn't going to be an option any longer, at least for the first few years. This is

going to be quite a big sacrifice when you really stop and think about it. What starts to happen is that this home, which you imagined would be your sanctuary, is becoming your burden.

Can you see where I am going here? Yes, the Universe brought you this option. It checks all the boxes that you imagined, but what you really wanted was not necessarily this specific home with all the bells and whistles, but what this home is supposed to bring you—your happiness and your sanctuary.

Many of us would still go through with the sale of the home, because in our imagination, we finally got the home of our dreams. Yet, what happens is, we become very stressed because we are working ourselves to exhaustion for our sanctuary, which is *not* a sanctuary at all. We are tired, resentful, stressed to the max, and not feeling happy. Was it worth it? Was that the feeling we were going for? I can guarantee that is not what we had in mind when we felt what being in our new home would be like. There are many of us who would be very tuned into our intuition and realize that this isn't what we wanted. We are going for the feeling of being happy in our new home. So, we decide this isn't going to work for us as a family; we pass and move on.

What happens next is now you realize very clearly what you desire. Your home must bring you happiness and reflect the peace of a personal oasis, and you stop worrying about all the bells and whistles. Being with your family and having time to enjoy your home is now a top priority, and working yourself to the bone is not worth it. Usually, very quickly after this realization, since you have become so clear and focused, the right home comes along. Especially because you had placed your trust in the Universe, and you released it. That is a big step, releasing it and letting go of any attachment to how it shows up. Next thing you know, you have purchased a new home without having to take on extra work. It is even better than you imagined, because it

is closer to the schools you wanted your children to go to. It may be smaller than the other house, but the way it is designed is better; the space is laid out perfectly, and the back yard is its own little sanctuary that you just love. Get out of the way, and allow the Universe to surprise you a little bit.

These same things apply to every area of wealth and abundance in your life. You decide financial wealth is something you desire, yet taking a certain job that would offer you that wealth doesn't feel good inside. Are you selling yourself out to get what you want? Getting clear on what you think you want is imperative. Connect with yourself. See what feels good, and what doesn't. If something doesn't feel good to do, then don't do it. You may make a financial killing, but if it leaves you hating yourself, it is too high a price to pay, in my humble opinion. Can you make a living and be abundant doing what you love? Yes, you can! I believe wholeheartedly in that. The only things that limit you are your beliefs. I talked about discovering our limiting beliefs earlier. If we don't feel we deserve to have what it is we say we want, no matter how much work we put into it, it will not manifest.

I want you to think about money right now. What does that bring up in you? What beliefs around money do you have? Do you have a story that says you must work hard to have money? Or what about, "Money doesn't grow on trees?" A big one is, "Money is the root of all evil." You want to have money, but you think it's the root of all evil in the world. Do you really think it is going to flow to you? You think it's evil, so you block it. Who wants evil money? Evil money is terrible; I don't want to be evil. That is the story you tell yourself. What is your family's money story? I can almost guarantee you have taken on that story. If your parents never had enough money, do you never have enough money? If your parents worked hard, and were stressed over whether they made enough money, do you

feel the same kind of pressure to earn enough? Our money stories are easy to discover. Go over your family history, especially your parents, and you will find your money story. If financial abundance has always been your issue, you have a money story. It may be buried, but it is there. If it weren't running the show, you wouldn't be having money issues. Money is only another form of energy, and there is plenty for everyone. It is just an energy exchange for goods and services, and if you want more, there is no reason you cannot have more. You just need to find out why you are blocking it. Find that out and clear it. Things will begin to shift. I have had a money story. My money story was, *I have just enough to get by.* Guess what? I always have just enough to get what I need. I have shifted that story, but it is a continuous process that I work on. Old habits die hard, and I must be vigilant in my thinking and beliefs.

Clearing our blocks to receiving is something we must do in our manifesting practice. The Law of Allowing is just as important as the Law of Attraction in manifesting what we want. We often stand in our own way of receiving, either because of limiting beliefs or, because our ideas of how things need to look when they show up. Many times, what we wanted shows up, but we push it away, because it came in a different form than what we expected. We ask for abundance, and in our heads, we have a picture, and the Universe says, "Here it is!" We push it away, because we had an idea of what color it should be, what job it might be, or what vacation we had imagined. It is crazy, but we do stuff like that all the time. Take a minute and think of a time when you asked for something and it came in a different package than you pictured, and you rejected it. It happens all the time. Becoming aware of our judgements is very important. When what you want shows up, take a moment and allow yourself to receive it and be thankful. If you find yourself not being able to receive it, find out why. Do you feel not good enough to have it? Do you feel you don't deserve it? Because if you feel that way, you will not hold

onto it for very long. For example, it is incredible how many true stories there are about lottery winners losing all their winnings. If you look at why so many end up losing all the money and going broke after a few years, you can see clear evidence that they didn't feel they deserved to win that money. If they did, they would still have it. Energetically they couldn't hold it, because they weren't a match for it inside themselves.

I cannot stress this enough! Find out what stories you tell yourself. Your beliefs run the show, and the Universe will always respond to what we believe about ourselves. If you want to know where you are in your belief system, look at what you want that you don't have, and ask yourself why. The answers are there. By taking the time to do a little archeological digging of your psyche, you will discover a gold mine. Don't you deserve to know? If it were a loved one, and they were struggling with something, you would go above and beyond to understand "the why." Give yourself that same consideration. Love yourself above everything else, and your abundance will grow exponentially. You won't even have to try; things just show up. You will become a master manifestor.

I have some wonderful exercises to do to help us shift our money stories. It takes some time to do them, and you can work on them a little every day, but I highly recommend doing some of these to help shift old belief systems. These are wonderful for attracting more wealth and abundance into our lives.

Wealth and Abundance—Tips and Techniques

Money Grows on My Trees

1. My Fortune 500 Exercise—This is a very powerful exercise in shifting our money stories. When we think of what we would do if money was no object, the first things that come to mind are everything we could now buy. This exercise is somewhat different. The object of this exercise is to get into the feeling of what it would be like to be able to use our money for whatever we like—whether that is buying a brand-new car or paying for a new home for a loved one. There is a feeling that goes along with having that financial freedom. There is value in what having money could do for your life. That is what we are tapping into. All you need for this exercise is pen and paper, and of course, time.

For example, if your family has value to you, you might think about all the ways in which having money supports that value or family in that instance. If art has value, how are all the ways can money support art as one of your values? Let's say animals have value to you, how many ways can money support your value of taking care of animals? You can apply this to anything you can think of. Think outside the box. You are retraining your brain and sending out very clear messages to the Universe.

▶ Get a journal and set aside some time for yourself every day to do this exercise. On the front page, write down *My Fortune 500*. This is your private journal.

▶ Write down 500 ways in which money supports your values, and what it would feel like if you had more of it. Do not think of the money per se; think about what has value to you and the correlating feeling.

▶ Each day take ten minutes to write down ten things until you reach your 500. This may take you a couple of months to complete.

▶ When completed, put your journal away, and come back to it when you notice your financial abundance shifting. Check in with what you wrote down. Notice how those things have manifested and make note of it.

Five hundred is a lot, but I really want you take on this challenge. Take your time, keep adding to it. Challenge yourself, but complete 500. Do the same thing if you want to manifest a new career, but on a smaller scale. Write down 50 ways a new career can and will support you.

2. Crazy Money—How much money do you want to manifest by the end of the month or the end of the year? Now write down as many examples as you can of the different ways that money might come to you. The crazier the better!

▶ For example, you receive a check in the mail from your Uncle Herby, who left you ten thousand dollars in his will. You think, *who is Uncle Herby? I don't know who that is. Could this be for me?* You come to find out you had a reclusive uncle who lived in a cabin and had no other family. His lawyer tracked you down, and you received a check for the money you requested.

▶ This game will get your imagination flowing and open you up to new ways of receiving money.

3. The Happy Message—Tape a dollar bill to a Post-it note or a piece of paper. Throughout your day, find places to hide the money—public bathrooms, grocery stores, farmers' markets, bookstores, etc. The possibilities are endless. Attach a positive message to the note to be found by a random person.

▶ For example, you could write, *This is happy money, enjoy.* You can get creative with your messages. Affirm this money will come back to you, then go about your day.

▶ Play this game when you feel inspired, a couple of times a month or so. An added benefit is it makes you feel so good!

4. Yay, It's Bill Day—Instead of dreading paying your bills, thank them for supporting you in your life. Thank your mortgage or rent for providing the roof over your head. Thank your car for getting you around. Thank your utilities for water, heat, or air conditioning. You get the idea.

▶ For example, you can also get excited by pretending the bill is a check. Whatever the amount is, add a zero to the end and imagine it's a check made out to you for that amount. Keep track of how much you are earning each month.

▶ Do this however often you pay your bills, whether it's once a month or two times a month, online or paper bills. This will change your vibration regarding your bills, making it a more pleasant experience.

5. For the Abers—This game is one of twenty-two processes in the book, *Ask and It Is Given,* by Esther and Jerry Hicks (based on the teachings of Abraham)—a very popular book about manifesting and being in the energetic vortex to receiving what it is we are asking for. I love this game. When I play it, I let my imagination go wild.

▶ For example, the authors suggest that readers place $100 in a pocket or purse and carry it at all times. A $20 or $50 bill will work too, but $100 is better. As you go through your day, think of things you could buy with the money, *I could buy that. I could do this.* If you spend that $100 mentally

one thousand times, you have vibrationally spent $100,000.

▶ By mentally spending this money again and again, you practice the vibration of financial abundance, and the Universe responds to your vibration by matching it.

"Love is the great miracle cure. Loving ourselves works miracles in our lives."

Louise Hay

"True happiness is not attained through self-gratification,

but through fidelity to a worthy purpose."
~ Helen Keller

Part Four

Career and Life Purpose

"When you are truly clear about what you want, the whole universe stands on tiptoe waiting to assist you in miraculous and amazing ways to manifest your dream or intention."

—Constance Arnold

Are Career and Life's Purpose the Same, and Can They Be in Harmony?

Not everyone's career is meant to be their life purpose, and that is fine. However, your career can, and should, at least be in harmony with your life's purpose. What does that mean? An easy example of what this might look like is a parent who works as an architect. Being an architect is something that person loves, it pays an incredible salary, yet their life's purpose is raising their children. Possibly, you work in education, and it is very fulfilling, but your life's purpose is volunteering at an animal shelter. If you reconcile those two things, and make it work in your own life, then you are in harmony. If working as the architect or teacher, for example, gets in the way of what you really want to do, and leaves you drained, lacking time to spend any energy where you really want, then you are not living in harmony.

It is wonderful that we are all individuals, each with a unique life's purpose! So, how do we discover what our purpose is? Do you know what yours is? It took me a while to discover mine. Many people have no idea what their purpose in life is, and can't even fathom living it through their career. They think of their jobs as something they must do to pay the bills. Unfortunately, many walk through life miserable with what they do for work. No one wants to lead an unhappy life, and wake up with a sense of dread every day because of where they spend most of their time.

How do you discover what your life's purpose is? I am going to separate career and life purpose for the moment. If your job is important because it pays the bills, and you cannot leave it, that is fine. You can still go on a journey to find your life's purpose, and possibly in the future, it may transform into your career. Many have started out doing something they love that they would have said was their hobby, which grew and grew, and turned into a lucrative

career. Others prefer to keep them separate. I have a fine art photographer friend who refuses to do commercial photography. She has told me that her love of creating art is what feeds her soul, and she doesn't want that to change by making her living doing commercial work. She doesn't want to burn out taking photographs of things she doesn't care about, just to pay her bills. Her career is an accountant. That is what she enjoys doing, and it pays her well. Her photography is where she feels connected and inspired, and according to her, that fulfills her purpose in life.

A good way to know if you are living your purpose is how it feels. When you are doing something, and it is feeding your soul or your spirit, then you have hit on your purpose. The problem is a lot of people have no idea what that purpose could be. They become overwhelmed with the stress of day-to-day life, work too much, have barely enough time to sit down and eat, let alone find the time to figure out their life's purpose. However, you must go digging if you want to find out. You must make the time somewhere in your life to explore, and see what you hit on. I don't buy the story that there isn't enough time. That is just another tale people tell themselves, so it becomes true for them. When people really want something, they find a way to do it. When they are afraid or really don't want something, a million and one reasons will come along to confirm that belief. It's the Law of Attraction in action. I have created a list of questions that will help you narrow down and clarify what it is you secretly want to do. It may be so hidden inside you that you haven't thought about it for years. Let these questions be your guide to help you figure it out.

1. What does your eight-year-old self dream about?

2. If you could never be embarrassed, what would you do?

3. What are the things you do sometimes that make you forget to eat or sleep?

4. If God came to you and said, "I am giving you the power to change the world!" What power would that be?

5. If you found out today you had exactly one year to live, how would you live that year?

6. If you could get paid to do what you love, what would that be? What does that look like?

7. Imagine you are one hundred years old and you are telling your great-grandchildren about your life, how would you like them to know you?

8. You get to come back to speak at your eulogy, what would you say about yourself, and how you lived?

9. Imagine in an alternative Universe you would never be judged for doing what you loved with your life, what would that be?

10. You have been given the gift to live ten lives. How would you live each one?

I use these questions to help guide people before they sit down to make a postcard. When you see what your answers are, you may be surprised. Thinking of what you dreamed about as an eight-year-old, something that you hadn't thought about in years, will light a spark inside and prompt you to delve even deeper and discover more. You start to connect to your heart and what makes it sing. Anything you do that makes your soul soar or that fills your life with joy is the answer.

For example, let's say that your career is a biologist, and although you enjoy your job, you don't feel that soul connection while you are doing it. You want to do something that touches your heart. You remember that you used to love to dance. Every time you would dance, you would tap into that creative energy, and you loved it! You haven't done it in years. After going over the questions and

seeing your answers, you discover that you had forgotten how much joy you felt when dancing. You decide to start dancing again. You set your intention on finding the time to do that. The Universe heard you, and it will present you with opportunities to bring dance back into your life. You randomly receive an alert for a new meet-up in your area to join a tango group. You used to love to dance the tango, and you think, *Wow, how interesting—I think I may go and check it out.* Before you know it, you have reconnected with something that sparked your passion. You meet new amazing like-minded souls who share your passion for dance. Each week you find yourself dancing, and you see how good you are. You are so good, that you are offered an opportunity to do some traveling with a new dance troop. You start going to exotic locales to perform, and you are able to travel to locations you wouldn't normally go. You get exposed to new people, new cultures, and new adventures. All of this just because you said, "yes," to the inner voice that was waiting for you to discover your life's purpose or passion. It goes even further. You now have been offered to take over the dance troop, and they want to pay you, so you can leave your job as a biologist if you want. Making the decision to leave the job or not isn't what is important or the point. The point is you have opened yourself up. You have touched a place inside that feeds you. Your energy is expanding, and it is touching everyone you encounter. You are fulfilling your life's purpose.

Many people believe career and purpose must be the same thing, and also believe their career and life purpose have to be things that change the world. That is incorrect. Most of us will not change the world like Martin Luther King or Madame Marie Curie, and we are not necessarily supposed to. Not everyone has the same purpose in life. Changing the world isn't our *responsibility*. Our only responsibility is to change *our* own world. There is always a butterfly effect when we shift something. Sometimes, the butterfly effect is big enough that it becomes transformative on a global scale.

More often, though, it ripples on a smaller scale limited to our friends, family, and community. People are often inspired and influenced by being in the energy of someone who is living in joy and passion, and that's contagious! Not a bad thing to catch, in my opinion.

I recently heard a story of a ninety-seven-year-old woman in a small town in England who is her town's dog-walker. She goes to the shelter daily, and takes the dogs out to enjoy the fresh air and get some exercise. She also walks dogs for friends who are no longer able to exercise because of old age or illness. Listening to her speak, you can tell she is living her life's purpose. She makes no money from doing this; she does it every day no matter what the weather. She is as sharp as a tack, and says she feels the same way she did when she was fifty. I thought, *This woman is living her joy.* She is incredible, and age has nothing to do with what is in her mind. She has greatly touched the people of her little town. They look forward to her visits, and are influenced by her spirit. She brings joy not only to the people she comes in contact with, but to all the dogs that look forward to their daily walks. She is loved in her community and is making a difference. I wanted to share this story to show what it can look like. The only thing that stops you is you. At first, it sort of stings to realize we are responsible for our own lives and cannot blame our circumstances on others, but if we can flip that thought process, we can see how great it is that we have control over living our lives with purpose. Look at how powerful that is!

I know a man who became a lawyer, and if you asked him, he would tell you he his family pushed him into that career. His father was a lawyer, so it was expected that he would follow suit. He never liked it from the beginning. Even when he was studying law, he felt this niggling inside of him that he wasn't doing what he should be. However, he didn't want to disappoint his parents, especially his father, and he really didn't know what else he would do with his

life. So he figured, why not? What will it hurt? At least he
would make a good living. As time went on, he took on
more cases, doing what he thought he should be doing to
build his career. He was slowly dying inside. Every day, he
despised his work more and more. He hated his clients;
he was a defense attorney, who defended many people he
believed were guilty of the crimes they were accused of,
many of them horrific. He started to fantasize about leaving
his job; he would play out different scenarios in his mind of
how he might escape. He came across my Postcards to the
Universe project through a mutual artist friend and created
a postcard. I can't really say he created a postcard. He wrote
on one of mine, and all he wrote was, "Dear Universe, lead
me in a direction where I can find some joy." Considering
the many postcards I receive, this one was pretty plain—
one sentence across a black-and-white picture of an old
telephone I had. He liked it; he said it reminded him of his
family's phone growing up. I hadn't thought about it, until,
recently, when I saw our mutual artist friend, and I asked
about him. She proceeded to tell me that shortly after we
met, he had a heart attack. He survived and decided it was
a sign, and he was changing his life. He told his family
that he felt this job as a lawyer was killing his spirit, and
he believed it was also a factor in his heart attack. He quit
being an attorney.

For about six months, he fluttered around. He made healing
his priority, and he started to take some courses to get
his teaching certificate. He always thought he would be
a good teacher because he loves sharing his knowledge.
He had a preconceived idea that being a teacher meant
barely making a living and working in a thankless job. Since
his heart attack, he had a change of heart—literally and
figuratively. He sold his expensive apartment and moved
into a smaller space he felt better represented where he was
energetically and emotionally. He also changed the city
he lived in. He applied for a job in a lower socioeconomic
school that had high crime and high dropout rates. He felt

he had something to offer. He wanted to reach children before they got into the criminal defense lawyer's chair. He wanted to be a strong influence in these children's lives. Once he started, he knew he had found where he belonged. He has made an impact on some of his students, and they on him. He knows he found his joy. Even though he makes nowhere near the same amount of money, he feels better fulfilled in his life. He said that having the heart attack was one of the best things that happened to him. When I spoke with him, I asked if he remembered writing on the postcard, and I reminded him what he wrote. He said that he had chills after I told him and had completely forgotten. His words, "Well, I guess I got what I asked for."

I just laughed and replied, "You think?"

I wanted to share this, because it's an important example of how someone who started out in one career, doing what he thought he was supposed to be doing, wound up in an entirely different field, where the new position reflected his life's purpose. You don't have to have a life-changing illness to make dramatic changes, but it does show what can happen when we work in a profession we hate, and it is eats away at our spirit.

I have a wonderful example of a technique you can implement to help you get into the energy of living your joy, your passion, and your life's purpose.

"Your life is the manifestation of your dream; it is an art. And you can change your life any time you aren't enjoying the dream."

—Don Miguel Ruiz

Career and Life Purpose—Tips and Techniques

The Path of Ease

The Path of Ease is a visualization that clears blocks in your path and leads to discovering your life's purpose with ease. This visualization can be done either sitting or lying down, or you can do this visualization as a walking meditation. If you do this as a walking meditation, I recommend doing it somewhere in nature, like a woodland path, park, or at the beach. Give yourself at least fifteen minutes to do this visualization.

▶ The first thing to do is take five, slow, deep breaths all the way into your solar plexus. Count to five as you breathe in, hold for five seconds, and slowly breathe out to the count of five. This starts you off in a more relaxed state.

▶ Set an intention that you will release all blocks inside of you, and you will feel at peace and at ease inside your mind and body. You have made this as a declaration.

▶ Imagine you are going on a walk in a beautiful, natural setting. That is why you can also do this as a walking meditation; you can use your physical environment, if it is serene and calming. If you are lying or sitting, close your eyes and use your imagination to conjure up the setting that offers you the same kind of tranquility you'd find if you were there. Picture yourself in your beautiful environment exploring your surroundings.

▶ You come across a magical wizard. He approaches you, knows who you are, and is excited to see you. He tells you he has something special for you. He hands you a golden egg, and tells you it has magical powers. The golden egg can reveal to

you how you can be whomever you want to be. It also shows you all the steps it takes to get there. You have been given foresight to your future self, living your passion. You see how easy it will be to get to where you want. There is no struggle, no resistance, and no hardship. You have been given a path of ease to your destination. You have been given this precious gift, with one condition, you must say, "yes."

▶ To say "no" would be an insult to the wizard, and to the Universe, who has gifts to give you. The wizard reminds you that it is already done, and all you have to do is take each step necessary to achieve your goal. You have no need to fear or worry, because it has been destined. This brings you great comfort, because you have a guarantee that your desire is there waiting for you. All of the answers are inside the egg. Crack your egg. What is inside?

▶ The wizard asks you to think about the next steps you must take to live out your dream—your life's passion. Think about each step and picture yourself doing each one. Take your time with this part, and let the answers reveal themselves to you. They will come to you as insights. The wizard asks you what you will do next. Share with him the revelations that come to you. Remember, there is no resistance as it is already done. You have so much joy inside you as you imagine what is coming. Get into that feeling of joy and ease. Feel into your body and notice how calm you feel. Notice how happy you are inside. That is the feeling you'll want to hold onto. The Universe responds to our energy, so holding onto that feeling of joy and expectation is important.

▶ When you open your eyes or, if you did this as a walking meditation, get home, write down all the revelations that came to you. This is important as new insights will spring from your initial ones, and will be a guide to show what you need to do next to achieve this dream. If you get stuck, go back and repeat the meditation, and ask for new insights or what your next step needs to be. You can also keep doing this mediation to keep you connected to the energy.

Tailor it to fit your personality. You can change any part of it if you want. If you prefer, you can meet your higher self, your guardian angel, or a magical creature. You can start the visualization by imagining you've already reached your goal and work your way backward, noting each step you took to get there. Make it as detailed in your mind as you can, and really tap into how it feels. This is a powerful visualization!

Part Five

Manifesting Your Masterpiece

"Everything you can imagine is real."

—Pablo Picasso

Creating a Manifesting Postcard—Tips and Techniques

I teach a workshop titled Manifesting Your Masterpiece where I guide people in creating a manifesting postcard. We start out with some writing exercises where we get very clear on what we want to bring into our lives. I have found that many people have no idea what they want that will bring them change or joy. They will say, "I need more money." Or, "I just want to be happy." When I inquire and ask what will bring in more money or make them happy—they have no idea. So, getting clarity on what it is that you really desire is the first step. Below is a small example of some of the important writing exercises I use to guide people to a state of clarity.

1. List examples of things you judge as being either good or bad that keep showing up in your life?

2. What do you want to create in your life? Think of all the different areas of your life—financial, health, relationships, career, and spiritual—and write down one thing that you would like to create.

3. Now write down what's really happening right now in these same areas. What is your current reality that you want to change, and why do you want to change it? By getting clear in what you don't want, you can get clear in what you do want.

4. List ten things you love to do that bring you joy when you do them.

5. What don't you want any more of in your life?

6. What does it feel like to have this thing in your life that no longer works for you?

7. What do you want to bring into your life to replace what is no longer serving you?

8. How will you feel when you have that
 experience?

9. Beside each of these things, list what stops you
 from doing it. It could be something inside, like
 fear, or an outside issue, like lack of money.

10. Take two things from your list that hold the most
 joy for you, and think of one step for each that you
 can take to bring these things into your life. Keep
 adding to that list.

11. Mark your calendar with a date and a time that
 you will bring each of these joyful activities into
 your life.

After we go through the writing exercises, I bring out
all my craft supplies and we make postcards. Making a
manifesting postcard is fun and easy. All you need is to
take the time for yourself, get some magazines or print
out pictures from the internet, maybe take a trip to a craft
store or dollar store. You can paint if you feel so inclined.
You can draw or you can use images you find, and paste
them on the postcard. Think of it as a mini-vision board.
I usually tell people to keep it simple, meaning to only
focus on one or two things for each postcard. You must
trust your intuition, but you can make as many postcards
as you like. I have some clients who have sent me many
postcards representing different areas of their life they
want to manifest. I ask each person to place a statement or
affirmation on their postcard. Some do this with images,
others prefer to write on the card, and some find the words
they want to use and cut and paste. The point of creating
the postcard is that you're putting your energy into it, and
the Universe responds to that.

I have found that when I get resistance from people, they
aren't ready. They think they are, but will find a hundred
excuses for not participating. But I find it amazing that,
after I gently nudge them, and they begin creating one, I

hear how much they loved doing it. They gave themselves the gift of play, because that is what it is. When we start creating, we tap into the same energy we had when we were children at play. That is what makes the postcards so powerful, and why children are so amazing at manifesting. They are fantastic at using their imaginations and creating. I help people tap into that energy.

After the postcards are finished, I ask everyone to take a photo of their postcard, and either print it out, put it somewhere they can see it on a daily basis, or use it as their screen saver. I advise people to keep it in a location that allows it to constantly seep into their subconscious. Each person must leave their actual postcard with me. That is tough for some people, but part of the magic is releasing the card to the Universe. For those who want to participate and create a postcard, but aren't able to come to one of my workshops, I offer another way to create one. It's simple. Just make one at home and send through the mail. I imagine the Universe saying, "I received your postcard with your desires, and I am on it, so be on the lookout."

Part Six

The Postcards

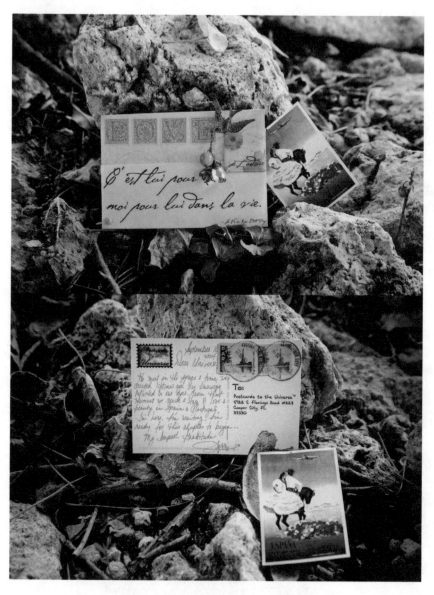

"We meet in the space & time we created lifetimes ago..."

—Terri

My Wandering Heart

Chicago is my hometown. Although I've lived in foreign countries, I've always lovingly referred to my home as *Chi-Town*. I learned to speak Spanish as a child while living in Mexico for several years, and I have also called Argentina and Spain home, although for limited periods. That's not to say that I don't dream of living in these places full-time.

As a child, I was brought up to be practical, and not have delusional hopes. So, in keeping with that, I studied accounting and became a certified public accountant. My delusional dream of becoming an actress pursued me, however, and at the ripe old age of thirty-eight, I finally became a professional actress with a small bit part on HBO's *The Mind of the Married Man*, which shot its exteriors in Chicago.

During these years as an actress, I followed my wandering heart, and traveled with my dear flamenco teacher, Rosa Maria Cello, to her homeland of Spain, where I developed a love affair with that country. We danced flamenco at *ferias* in Jerez de la Frontera and Cordoba. It was the first of my many trips to Spain, and I can say wholeheartedly *that my heart belongs to Spain.*

My dance passion did not end with flamenco. Tango appeared in my life quite suddenly, and I was taken with it, as if by a fever. So I traveled to Buenos Aires to eat, sleep, and breathe the Argentine tango. It was a fantastic journey into the understanding of a complex dance created through an intricate improvisation between partners. It is a dance of passion, desire, and sadness, and I relish knowing its secrets.

Although I was married during these years, my husband and I grew apart early in our marriage after an infidelity came to light. Our marriage never recovered, although there were attempts on both sides to resuscitate it—it was

dead on arrival by 2012. An issue with our finances led me to uncover some very shady dealings that my husband was formulating through his multiple businesses, and I confronted him with my findings.

It was then that I had my *aha* moment—he slapped me, and that action literally knocked the sense back into me. The thought running through my head was, *This is not acceptable!* I literally felt a shift, almost as if a chip had been reprogrammed in my mind. No matter what it was going to take—I became determined to leave the marriage any way that I could, I vowed to myself.

Six months later, I was working at a Fortune 100 retailer, after leaving the corporate world seventeen years before. At my first interview out of the gate, and I snagged the job. I felt like the Universe was assisting me with my escape plan.

Melisa had asked me to create a postcard for her project, and I was delighted. I was ready to bring the relationship of my dreams into my life. This is one of many postcards I have created for *Postcards to the Universe.*

I am an ever-hopeful romantic, and the man I have been waiting for all my life finally arrived. I had recently re-entered the dating world online. An interesting occurrence happened. I had a date set up on a gorgeous rooftop here in Chicago and in he walked. We are very much in love and it has been more wonderful than I could have imagined. I finally have the relationship I have been waiting for my whole adult life. I couldn't be happier.

I believe the Universe conspired to bring the right person into my life. In addition, the Universe knows that my heart's desire isn't just finding my *soulmate*, but living in Spain... hence the small picture of Spain.

Just recently I was delighted to learn I am in fact going to Feria del Caballo in Jerez de la Frontera, Spain in May

next year. It matches the image of the card I included almost exactly!

Currently, I'm writing a memoir based on the dissolution of my marriage. *The Ashley Chronicles* came out of my investigations into my husband's nefarious money dealings, and this unexpected journey that led to my own personal empowerment and freedom.

"We meet in the space and time we created lifetimes ago… Our knowing reflected in our eyes. From that moment we create a story of love and beauty in Spain & Portugal. I'm here, I'm waiting. I'm ready for this chapter to begin… My deepest gratitude."

Terri Lopez

"There is beauty in the breakdown."

—Eliza

Heartbroken and Disenchanted

I am a wife, mother, and artist. I teach children how to get creative and make art. I feel it's a great outlet for kids to get in touch with their imaginations. I love what I do and feel happily blessed in my life.

Growing up, I was always interested in doing art for a living, and I have manifested that in my life. I also knew I was destined to become a mother and have a family. I wanted to start my family right after college; I wanted to be a young mother, so I could grow with my children.

In high school, I met and fell in love with a man who I thought was destined to be my life partner. He had confessed to me that he also wanted to start a family young, and together we were on that path. Our plan was to attend college together, each working in our perspective career paths. We were very much in love and things were moving the way I thought both of us had envisioned and wanted.

Shortly after starting college, the cracks in our relationship started to show. For the next six to seven years, the cycle of separating and getting back together repeated. I felt I was still continuing on the dream with him and so gave him the space to figure out what he wanted. I convinced myself that we were young, and women matured faster than men, and to just give him time. I thought he would catch up, and we would again get married shortly after graduation and start our young family.

Each time we would separate, the trust I had in him and us as a couple would diminish a little more. I kept trying to convince myself that it was meant to be, and it would all fall into place. He would tell me that he needed more time and that we should try dating other people to get it out of the way. That way, when we finally settled down, neither of us would say we missed out on our youth and dating.

I tried dating and did enjoy meeting some other people, but truthfully, my heart wasn't in it. It was still with him. He, on the other hand, was having a grand old time doing whatever he wanted and knowing that when he was ready, I would be there waiting.

The cycle continued, and I was becoming more and more disenchanted, yet I still held on to my dream and him. It became a joke in our family and friends circle, people would ask, "So are you guys together this week or not?" It finally started to wear on me. Every time we would reconnect it was filled with promises and then every time we would separate, my heart would break again. Our relationship was breaking down, and I didn't want to accept it.

Years of this went on and I let it, knowing that my dream of having children was moving further and further away. I kept going on deluding myself that he would change his mind. I put my life on hold for him, I moved for him and I waited for him.

Finally, I had enough. It dawned on me that I was no longer living for myself, but always for him and what his next move would be. I decided that I couldn't, or wouldn't do this dance with him. I finally accepted this was who he was, and if I wanted to have a family and enjoy my life, it was time to move on. I told him I had enough; truthfully, I don't think at the time he believed me. I had said it many times before, yet I still was always there. I was heartbroken. I don't think I ever really dealt with my heartbreak, I just dove into my career and completely focused on that. I stopped allowing myself to think of marriage and family. Looking back, I now realize that during that time, I honed my career path and teaching art became my priority.

A few years later, I met and married my current husband and did end up having my family, years later than I had

envisioned. That was okay. It worked out the way it was meant to, and I couldn't be happier.

I have to give my husband credit; he has a lot of patience with me. It took me a long time to trust and open up. He knew about my past relationship and feelings, and how heartbroken I had been previously. Trust has always been an issue of mine since that relationship, and it's something I have been working on.

Fast forward to this past year, and I took a workshop from Melisa Caprio on her Postcards to the Universe project. She was talking about the Law of Attraction, art, and making a postcard to help powerfully manifest something you want to bring into your life. She kept saying, "Watch how fast things begin to manifest when you create a postcard."

I was thinking, *Okay, sure, we will see.* I had decided to sign up for the workshop with a friend and thought how great it would be to do something like this with the kids that I teach. I wasn't thinking too much about manifestation for me; it was more about creating. During the class, I created a postcard about art and teaching. It was great, but nothing major as far as manifestations go because I was already doing that.

A few weeks later, something started to needle me in the back of my psyche, and I contacted Melisa and said, "I want to make another one and send it." She was excited and told me to let her know when I was sending it. All of my past emotions started to come out of nowhere. I don't have any idea why they came up, but they did. I felt that I was holding something back emotionally from my family, and I was still carrying around the hurt. It was starting to spill over in my relationship with my husband whom I adore. I had never dealt with my old pain.

I am amazed at what happened next. After I sent it in the mail, I already felt lighter. Later that day while I was on Facebook, I received a friend request from, if you can

believe it, my ex. I hadn't heard from him in over fifteen years, and on that exact day, he reached out to me. I was stunned. I emailed Melisa to let her know that I did finally send it and that it was already working. She, of course, wanted all the details. He then proceeded to write to me to let me know that he had been thinking of me, and how badly he felt about how he treated me over the years. He went on to apologize for his lack of commitment and all the ways that he had betrayed my trust. I couldn't believe what I was reading. It was extremely healing finally getting that apology and validation. In that moment, I completely let it all go. If I didn't believe it before, I certainly do now! It was an amazing experience and was thrilled when I was asked to share it. The Universe responded to me immediately when I was finally ready.

Eliza

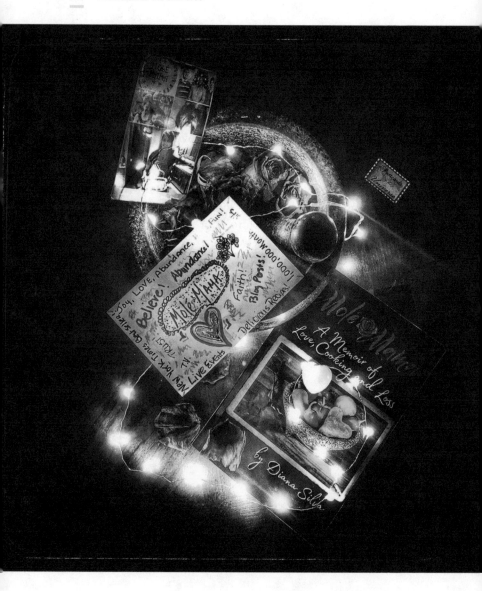

"Molé Mama, a memoir of love, cooking, and loss."

—Diana

Cooking Is My Love Language

Two years ago, I realized my lifetime dream and finished my first book. And while I spent countless hours writing it, and had tremendous support from friends and family, it started with a simple hand drawn postcard to the Universe.

I had the good fortune of meeting the fabulous Melisa Caprio, founder of Postcards to the Universe via a writing course we were taking. While her concept of manifesting your heart's desires by creating a postcard and mailing it to the "Universe" sounded interesting, I was skeptical. It was hard for my farm girl work ethic to believe that I could make my biggest dreams come true by creating a postcard and mailing it; frankly, that sounded too easy and too *woo woo*.

As I learned more about her movement, I found myself fascinated by the stories of her growing army of successful manifestations. People found their soulmates, new jobs, dream vacations, and so much more. My dreaming about becoming an author had created decades of partially written stories, hundreds of hours daydreaming about my life as a successful author, and anxiety that it was never going to happen.

I had tried so many gimmicks, and practices to becoming an author, and they all failed. I registered for Melisa's workshop, expecting it to be another failed attempt. But within minutes of her workshop, I found myself drinking her manifesting Kool-Aid and believing that maybe this could work.

Shortly after her workshop, I sat down with my markers one afternoon and drew from my heart about my new book, the people it would connect me to, and the joy I would know by living my dream. My postcard looked a like a seven-year-old's doodling, and I was embarrassed to mail it and have the postal employees, the very talented artist I was sending it to, and, well, the Universe, see it!

The moment I dropped it into the mailbox, something inside me shifted. Creating this card, signing it, and mailing it, felt like a legitimate contract to me. Maybe because I've worked in corporate America for more than twenty years, but it did. My little card launched my soul into action, brought new people into my life and almost two years to the day after I created my card, I was holding my first book in my hands.

There is something quite magical about manifesting your lifetime dream, and I'm thrilled to share my story with you and hope that you, too, will believe that your desires are just a postcard away!

Diana Silva

"I reinvent myself—I am a leader with great vision."

—Dana

Falling in Love with Myself

I remember creating this postcard, and I wanted to draw it because I really wanted so badly to be connected to what I was creating and believed that I could achieve it. Over five years ago, I was in the lowest point of my life. I had just gotten out of the most destructive and abusive relationship I had ever been in. My partner at the time had cheated, lied, and stolen from me in addition to leaving me a hefty balance to pay on a repossessed car which put me in debt. As I sat in my kitchen crying my eyes out, angry, sad, and embarrassed, I asked myself, *How did I get here?*

What I saw is that I looked past all the red flags, because I so desperately wanted to love and be loved. So I made excuses and refused to see the truth, until it got so bad that I could no longer avoid it. The Universe kept raising the stakes until I heard the message.

So I asked myself, *Do I really think I am the worst kind of human, the biggest piece of shit, phony, lying loser not worthy of being loved?* and the answer was, *Yes.* I was shocked, but there it was. The only reason I let that person treat me like that was because that was how I was treating myself. I saw that I was the biggest abuser in the room, slicing my wrists open thousands of times a day with the abundance of negative thoughts I would tell myself all day long. I had to put down the knife, but how? And if all the negative thoughts taking up all this space in my brain was not me then, *Who was I?* I realized that I had to start forcing myself to think affirming and positive thoughts, and any time I heard myself say something negative, I had to stop myself, and on purpose, change it to a positive even if I didn't believe it yet.

I went through a deep depression and shut down for about three weeks, crying and mourning the loss of my past identity, who I thought I was. The little girl that built up all

these walls to cope with life had gotten me this far, and I was thankful, but I had to let her go to create a space for the adult Dana to show up, heal, and take me to fulfilling dreams. I wrote my inner child a letter of gratitude and appreciation, thanking her for everything she did, and letting her know that her job here was complete and that I would take it from here. *So, if I am not everything,* I thought, *who am I? I* asked myself, *Who do you want to be? I want to be a leader, creative and fun.* So, if I wanted to be those things, what behaviors would be present? What would I do or say? I reinvented myself one day at a time.

I can honestly say I am in love with myself on most days, and the days that I am not, I know that is my cue to take care of myself and exercise good self-care. I am comfortable in my own skin, and give myself permission to do the things I love without strangling myself with the pressure to be perfect and care what others think. Now I live life for me, based on what I think is good enough. Either way, people may like it or not. I cannot control that. What I can control is my own happiness and feelings of completion, learning and growing, honoring myself by doing the best I can with what I have in every moment. There have been times I have fallen off the horse, and luckily, I am surrounded by friends who love and support me exactly as I am. I am so thankful for them. I am the closest I have ever been to realizing my goals and dreams. I have produced a feature film, was the story editor on a script, started an open mic, and launched a nonprofit called the *Arts Accelerator,* helping artists accelerate their careers in film and music. I am partnering up with other organizations to create more opportunities for artists in South Florida that provide real resources to give creatives access to sustainable careers in their fields. I have written and recorded new music and am creating my tribe of supportive and talented artists, and we are helping each other accomplish our goals. I am truly blessed and thankful, and when I made that postcard, I remember thinking, *There is so much on here, how is any of this going*

to happen? And then I thought, *I have to put it out there and let the Universe decide how it is going to manifest in my life.*

I feel like the postcard I created for *Postcards to the Universe* is still working and active. Every day, I take more steps to achieve my goals. The Universe is putting great people in my path, helping me along the way, and allowing those that are not aligned to fall off. I am stronger and ready to receive a bigger love than I ever thought possible. Now that I finally love and accept myself, I am so excited for the future.

Dana DellaCamera

"I have taken my power back."

—Laura

I Am a Survivor

My own life has been a journey of pain, shame, and humiliation since I went from an average teenage girl, then a victim of sexual assault, to a naturally spirited, driven woman, now full of grit, grace, courage, and resilience. I am proud that I am able to serve the victims and survivors of domestic violence.

I help educate and assist many of them to manifest a violence-free future for themselves and their families. I have gone from my near-death experiences of abduction, physical, emotional, and financial abuse in my past, to a self-sufficient life of fulfillment, success, and joy. I share my stories now and they have helped thousands of victims and survivors elevate themselves above the statistics. My movement, *Me Too No More,* has blown open the silenced crime of domestic violence.

I have manifested a non-profit foundation, an advocacy program, created a website presence, community messaging, a YouTube channel, a podcast, developed new, out-of-the box education programs to educate the masses, and created a new community for social change with events on domestic violence. Also, add some social media into that equation to share the secrets that were once silenced and the news that being a victim is over—*period!* We broke the silence. I intend to keep the truth out in the open and demand that the abusers take their own responsibilities for these crimes they have committed against victims and survivors.

To this day, I believe my purpose is to serve victims and survivors of such heinous crimes, and give them the power to heal and make wonderful life-changing decisions, like I have done for myself and my family. Domestic violence affects everyone. My first book to educate on domestic violence is titled, *The Secret about Domestic Violence They Don't Want You to Know.* It is available now on Amazon for

BY LAURA C. HUDSON, M.A.
VICTIM, SURVIVOR, ADVOCATE,
FOUNDER CEO OF ME TOO NO MORE

THE SECRET ABOUT
DOMESTIC VIOLENCE
THEY DON'T WANT
YOU TO KNOW

Domestic
Violence
is a CRIME!

= POWER

ME TOO ★ NO MORE

those wanting to know what warning signs and red flags to look for from those they trust. My experience as a victim and survivor has made me an author, advocate, founder, and CEO for the *Me Too No More Foundation, Inc.*

We do everything we can to assist those in a domestic violence situation, and are ready to commit our lives to creating a violence-free future through empowerment, self-love, healing, and creativity. To reclaim your new life from violence and abuse is so powerful to the mind, body, and spirit. You deserve to live a life free of abuse, to know and feel safety. Not to live and breathe in fear, not to cower in a corner, cover your face, being afraid to speak, or be controlled and harmed by someone who claims to love you. That is not love. Love is caring, nurturing, and supportive. If you know someone is being harmed, say something, reach out to my organization for guidance, counseling, self-defense, education, and more.

MeTooNoMore.com is here to create violence-free futures for you and your family. I have dedicated my life and fulfill my purpose serving others. You are enough and you deserve the best in life. This silence is broken for you to make a new life today. I encourage and inspire you to know you can have more in this life, and to manifest your dreams. Manifesting new opportunities and creating new challenges each day strengthens your mindset to achieve amazing life-changing events and learning experiences, and you will want to continue to elevate to new heights. Manifest your future today. I know I did.

Within just a year after creating my postcard for *Postcards to the Universe,* I have manifested my book, speaking engagements, radio shows, and outreach programs. I have also recently been asked to consult and work with the hospitals to help bring awareness to this epidemic. Together, we are making a difference.

Laura Hudson

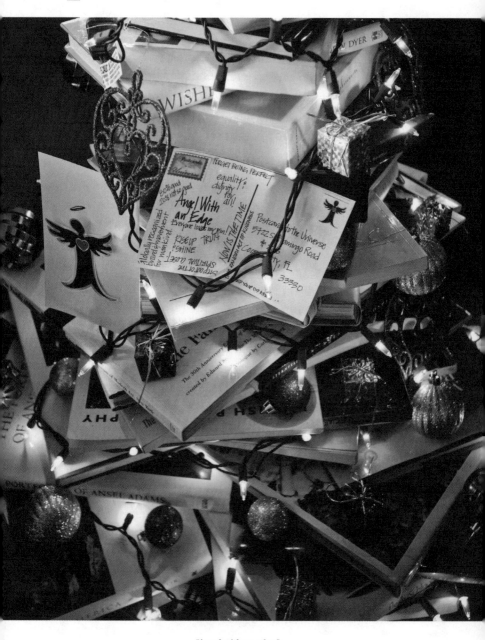

"Angel with an edge."

—Elizabeth

Learning to Fly

A postcard usually represents a journey, and when I made
my first postcard for *Postcards to the Universe*, I had no
idea how big the journey I was about to embark on would
actually become. I have always been a creative soul who
wanted to make a difference in the world, but I just didn't
know how. I pushed through and persisted and did what I
always knew to do, I created beautiful things from my heart
with my hands, yet I always knew something was missing.
Like Goldilocks, nothing was ever quite right, and yet, with a
heart full of grief, I persisted.

You see, I'd lost my tribe—the women I loved most in this
world—my mother and my aunts—to breast cancer. There
were really two deaths the day my mother died, because I
had to learn to live in a world without her in it. These were
the most amazing, strong, trailblazing tenacious women
I'd ever known. I knew I needed to honor them and create
my own tribe. So I decided I was going to build an army of
earth angels—a tribe of people who were roughly twenty
percent rotten and eighty percent good, and that everyone
could pick their own ratio. *Angel with an Edge* was born;
it was just a seedling when I met Melisa, and I created
my first postcard. It was a beautiful purple angel with an
open heart in the center of her chest ready to take on the
world! Her feet on the earth, an open heart, and her crooked
haloed head in Heaven with spirit. I had no idea what that
would transform into. I submitted my book proposal to a
big publisher on Christmas Day—the day my mother had
passed—somehow that felt fitting. Just a few short months
after that, I had an emergency surgery that no one could
promise I would walk away from, and a three-year journey
of the dark night of the soul began.

During this time, I went bankrupt professionally and
personally. I lost my beloved artist-owned business of
twenty-five years, and I lost some friends I had counted on.

I felt abandoned, and I did what I always knew to survive, I persisted. Oh, and that persistence had worked for several decades, until my entire existence was threatened with extinction, and I woke up and realized everything I thought would kill me had already happened. Every fear I had of showing my gifts and my abilities to the world couldn't possibly be worse than nearly losing my life. I reacquainted myself with the wise soul who had never abandoned me, always protected me, and kept my gifts safe—the one who kept my wings all these years, waiting for me to show up!

As I healed, I remembered her...the soul I came here to be. She didn't know how much she had known about others' feelings back then. She just knew she felt them, and they paralyzed her with self-doubt. She didn't realize until nearly half a lifetime later, that as a small child, she felt the damage and hurt in the energy fields and bodies of the people around her. In her child's mind, she translated the emotions, feelings, and judgements adults carried, with their own belief systems and fear patterns. As a result of this, she spent most of her life believing she was not worthy. She felt that until she could be *enough,* she was truly not worthy, and certainly not enough. She felt she was trapped in a small body, with a small voice that was stifled and quieted, and nearly always felt shamed. She learned at a very early age her authenticity, honesty, and her *gift* of knowing things about others was not something that was admired, but feared! She also learned that if I made her small and shut this down, she would *fit in.* When I finally listened to this little angel, she said to me, "You've finally arrived. I've been keeping your wings for you, and it's time you take a leap and give them a ride." And so, I embraced the keeper of my memories, and my wings, and I gathered up all the gifts the Universe asked me to receive and took flight on my newly unfurled wings. On this journey, I explored all the treasures inside of me that I had forgotten, and I unlearned all the things that never belonged to me to begin with. I met guides, angels, spirits, and ascended

masters, and I embraced my spiritual gifts and my inner-knowing, my truth.

I had started a movement called *Angel with an Edge* to help people learn to love themselves through everything—not just *push* themselves through anything. I became my own teacher and student. Learning to love yourself is the hardest thing you'll ever do. I can honestly say my biggest burden became my biggest gift. My ease and light at the end of the tunnel truly began when I realized it was all about my self-belief around worthiness and being able to receive. When I created my forest of self-love postcard, all this transformed my life in such a beautiful way. *Postcards to the Universe* gave me an outlet to create and explore, and it gave me hope and a vision of the life I am grateful for today.

When I say, "The Universe is conspiring for you," it's not an empty sentiment. It is not something I read on piece of paper or a fortune cookie. I believe it where my spirit meets my bones, because these bones walked it. I've become a self-proclaimed renaissance woman, earth angel, spiritual, artistic, intuitive, light-warrior, inspirational pizza pie, because that's how life goes sometimes. You never know exactly what you're going to get on each slice; you just know it's going to be mostly amazing.

I got to walk away from something millions of people could not—including three women whom I loved dearly, and ultimately lost. I honor them in my strength and my choice to constantly keep my heart open, allowing myself to be vulnerable, and I listen. I now have a tribe of loving souls on both sides whom I am so very grateful for. I listen to Spirit and my higher inner-knowing, because I've learned that Spirit has a much bigger knowing than I ever will. I went on a great adventure. I am learning to truly love me and being me, because I know of no other way to be. I'm also okay with growing old and embracing every damn bit of it, because I know some pretty amazing goddesses who didn't get that

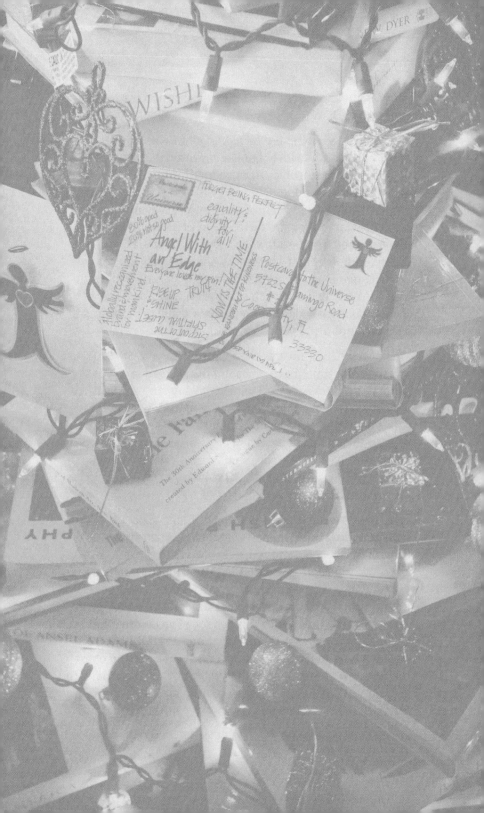

chance. It is a privilege, and I think I'll make a postcard about that...

I am an *Angel with an Edge*, I feel like Dorothy and Cinderella all at the same time, with wings instead of ruby slippers... And I'm here to tell you that fairytales do come true; you just have to create your own! And dream and co-create with the Universe. Cinderella had it partially right, she said, "A dream is a wish your heart makes," but I'll respectfully disagree, "A dream is a *reality* your heart makes." *Postcards to the Universe* helped make my dreams come true. Thank you, Melisa. I am eternally grateful to you.

Elizabeth Lindsay

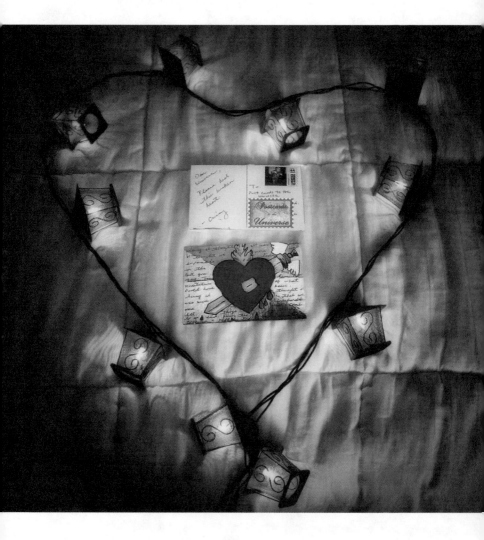

"Please heal this broken heart."

—Crissy

Letting Go

One of my closest friends told me about a project called *Postcards to the Universe*, and she thought it would be good for me to create a postcard on letting go. We have known each other since we were children, and she knew I was going through some things emotionally. She said she felt it would be a really good releasing exercise. I had never met Melisa, but reached out to her and said I wanted to create one. She explained the process of how it works, and I figured *why not*, it couldn't hurt. So I decided to make it around an old relationship that I had a hard time getting over. I was deeply in love with my high school sweetheart; we dated for five years on and off. As crazy as it sounds, twenty years later I still wasn't completely over him. I still wondered about him and kept hope that we would get back together, even though I had married someone else and had children. I was stuck. It didn't make sense! So much time had passed. When I heard about the *Postcards to the Universe* project, I thought I would give it a try.

In my postcard I was asking the Universe for help to finally heal my past and my broken heart. After about a week, I let her know that I finished it and would be putting it in the mail. About three weeks later, she contacted me and said she never received it and hoped it didn't get lost. I confessed that I was busy and hadn't sent it yet, but was going to get on it. It took me another two weeks to finally send it. I realize now that I wasn't ready to release it yet and saying I was busy was just an excuse. As soon as I sent it, something shifted; I felt less connected to my old thought patterns. I was finally feeling free from being stuck—no longer holding on to an old relationship. I don't know how it completely worked, but doing my postcard did help me become less attached and helped me let go of my grief and

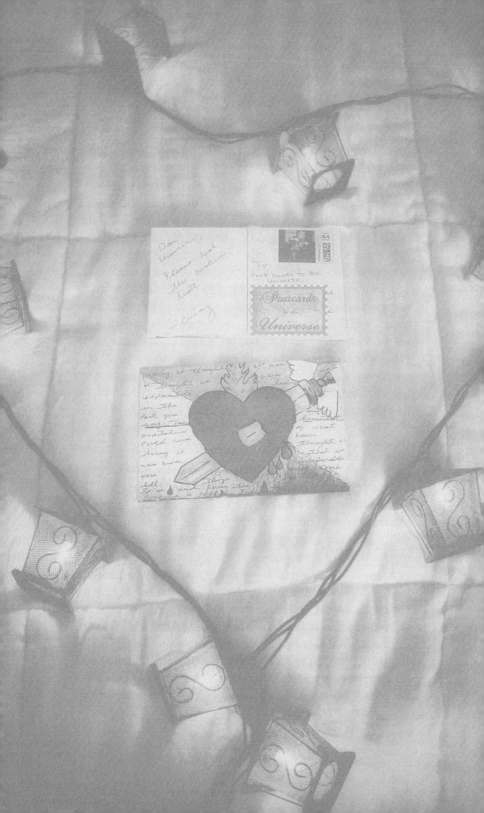

loss. I believe the act of creating a releasing postcard helped me finally get to the place where I was ready to let go, and I am so grateful for coming across *Postcards to the Universe.*

C. Millian

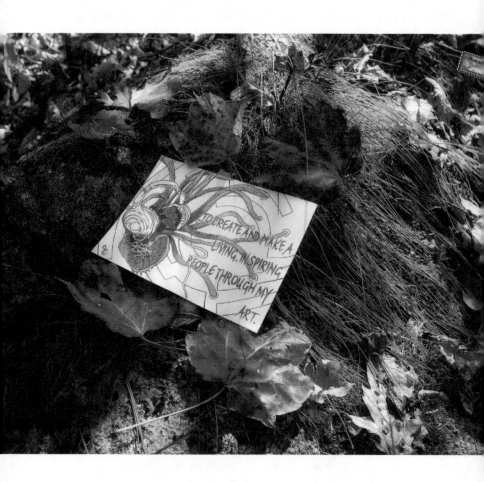

"I create and make a living inspiring people through my art."

—Jake

Creating Art from Chaos

Why do I create? As an artist who believes in the constant evolution of creativity, my objective is to always *say something* and utilize the materials at hand, to stretch my imagination even more. I truly enjoy the challenges of innovation and creativity. There's no greater excitement than to be presented with a unique opportunity, to listen to the stories, see the space, absorb the culture and brainstorm a unique concept from paper to its final brushstroke.

In my family, I am the first American born from a Cuban father and Russian mother—two very contrasting cultures. My parents were determined to become Americanized. My earliest memories are an intense experience with an immediate feeling of neglect, obscure perceptions of sound, my mom always under stress, and my father nowhere to be found. Being born into a broken system created a means for constant adaptation; riding the waves of humanity and diversity, where struggle is a daily part of life and clearly inevitable.

I always had the feeling of never being a part of the inner circle. My perception of the world was slightly distorted. Unfortunately, I was born with forty percent hearing loss in both ears. Since birth, there were tons of sounds I was missing out on. Let's just say, I was easily misunderstood and excluded from the circulating, daily functions at home. I was brought into a world of strange noises, different languages, a wide range of music, startling sounds, and hereditary emotions. I evolved to visualize the world within a muffled version of reality.

Subconsciously, I was building my techniques and experimenting with many aspects of the visual arts. Getting my hands dirty was just a way of life and the way I connected with the elements around me. Art eventually

became a way to channel that. Thank God for the local art programs. I have been able to feed my curiosity since I was six years old. I've dabbled with almost every medium I could, but working with woods and paints has always been my true love. I utilize a surreal organic imagery, with bold graphic line work and colorful contrast. I attempt to capture elements of my past and present in hopes of evolving to different intellectual and emotional levels in the future. Looking at imagery and objects has always fascinated me. I always mimic what I perceive in some way. Anytime I come across a different medium, I have to try it. I was far from a natural since day one. But I welcome hard work and consistency, which has always been influenced by the strong women of my family.

With a lot of physical and emotional abuse circulating in my home, I just dove deeper and deeper into my art to tune out the chaos. Later on in my life I had an opportunity to get reacquainted with my dad and moved to Miami. It started the culture shock all over. I had to start all over again with a new demographic in South Florida. I continued to create and paint even more and pursued a Bachelor of Fine Arts degree. I really understood that it was time to pave my own future, away from the family drama.

My drawing and painting only intensified. Now it was time for me to start really building a personal portfolio, and begin exhibiting and putting my stamp on the current art scene. Creating and experimenting with mediums has been the only constant throughout my life.

I was determined to be financially stable doing what I love. I've been fortunate enough to have numerous commissions on numerous surfaces such as walls, wood, canvas, apparel, surfboards, skateboards—you name it, I continue to apply my creative voice to it. I put my whole heart into each project I create. When I created a postcard for *Postcards to the Universe,* it reverberated with what I have already been doing my whole life as an artist. It was a confirmation of

something that I take great pride in—paying close attention to clientele and customizing imagery to really catch the creative vibe in the moment. I truly enjoy the visual experimentation. This postcard depicts a biomechanical heart which is iconic to the machine-heart and soul I put into my work, despite any obstacles that come into my path. I AM living my life's passion.

I truly love people, their personal journeys, and listening to their visions to enhance their lives. There's something beautiful in everyone and everywhere. I am glad I have an additional voice and use it to identify that beauty in my work.

Jake Cordero

"It's travel time."

—Jenny

Saying Yes

If someone offers you a free all-inclusive trip to Mexico, you say "yes," right? Of course. Because, if this opportunity came to you, all the things like childcare, time off work, and purchasing the plane ticket will fall into place with a little bit of finagling, sure, but you *know* you will make it happen. I know because this happened to me.

If you are now incredibly curious and wondering how I received this gift of a free vacation stay, it is simple. I asked. I put it out there at the beginning of 2018 that I needed more travel in my life. To further solidify my intent to the Universe, I even changed several of my passwords this year to include MEXICO, which means now I must change several passwords before this story is published; I am okay with that. I have a lengthy list of destinations I've requested the Universe to show me next.

There is a small part of me that considers travel requests to the Universe as frivolous. There are so many things to wish for of higher significance. We know there are worthy causes that need gifts, like children without homes or world peace. Personally, there were deep longings of my heart for connection and love. To understand the rationale for making travel of high significance this year, it requires looking back at the postcards for *Postcards to the Universe* I created in 2015. I was at a crossroads.

One of those great forks in the road of life, with shadows of uncertainty, was about my career, my next place to live, and the stirrings of my soul. The biggest unknowns were figuring out where I was going to live with a contract on my house, and where I was going to work next, as I found myself unemployed. I had to figure out where to grow new roots. With these heavy decisions, I sat down to create a few postcards. I pieced them all together regarding my next house, which, without question, included a pool. Every

manifesting project I have ever completed includes a pool. (Preferably saltwater, but who can tell from a magazine cutout image?) In my postcard, I included green trees, blue water, and adorable backyard patio furniture. Full-length windows along the back of the house surrounded this summertime oasis, postcard complete, check. Move states away, check.

There was no pool in my backyard, but I was inspired by the one in my neighbors' backyard—the live replication of my postcard. I asked the Universe for this beautiful landscape as I was looking on from the sidelines, and not the view out the windows! There was humor to be found in the Universe's answer to my request, and I was okay with this. Even without the backyard I had envisioned, I did make my way to a comfortable home in a warm weather climate. I settled into my new sunshine abode, with milder winters, beaches, and the blue ocean in close proximity. I accepted this reasonable trade-off from the Universe.

For the next couple of years, I didn't venture much farther than an afternoon's drive away. When you live in an area full of vacation destinations, you learn that most people are more than willing to travel to see you. I lived in paradise, but I began to miss the opportunity to explore new places. I wanted interesting people and unique culinary discoveries. I wanted to expand, and not just in my mind. I needed time away from work and daily responsibilities. I needed the new neuro pathways that develop from varied experiences and different views and sounds. I needed to be recharged so that my days would not feel so heavy. Time away is healing, and this is why I asked the Universe for more travel. Even when I learned about the Mexico trip opportunity, though, I did not know how much I would need the break. In the weeks leading up to my first international flight, however, I was not sure I would actually be able to leave.

Friend: "Hey, I have a proposition for you."

Me: "What does that mean?"

Friend: "Do you have a passport, and can you leave your son for a few days in October? I am a travel agent on the side and have a totally free trip to a five-star all-inclusive resort in Mexico. You just have to buy a plane ticket and transportation to and from the resort."

Me: "Sounds interesting!"

Followed by, "*Yes*, thank you Universe!" Be on the lookout for my next postcard to wherever is next!

Jenny Diebold

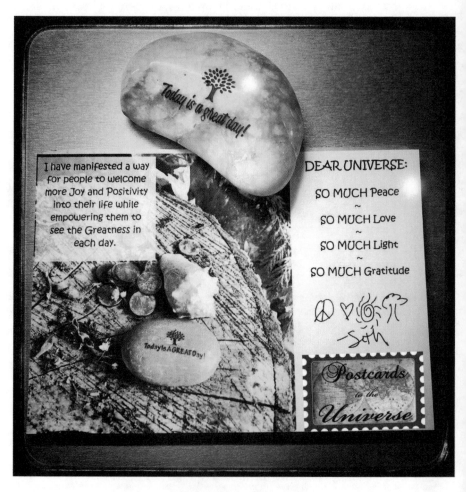

"Today is a great day."

—Seth

Today Is a Great Day

The *Today is a Great Day* project began as a mindful mission to progressively impact social media with positive vibes. I also began this mission at a time in my life where I was welcoming more positive energy into my world.

Each morning, I would wake up and post, "Today is a Great Day." Not only did this give my brain a kick-start in the positive direction for my day and set the intention of gratitude and appreciation, I noticed that it was also impacting my friends. Each day, the post would get more and more likes, and not from just the same people day after day. I heard feedback from several that it was something that other people really enjoyed waking up to in the Facebook newsfeed. I was affecting people in a positive way! I was encouraging joy! This absolutely thrilled me as I strive to truly live a life to spread positivity to others, raise the vibration, and help people realize the greatness that is truly around them.

I wanted to take it further. I thought and thought about ways that I could impact people, and enable them to impact others on a grander scale.

I remembered a conversation I had with a soul brother of mine. He showed me a picture of a rock that someone had painted on with some words of gratitude and left behind for others to find. *Light bulb!* I immediately began researching opportunities and ways to make this passion project work. I recognized that I could embrace the fact that I have a job that has me traveling all around the United States on a regular basis. I could lay these stones out in the different cities I go to, and people would be able to find them, take a picture of them, post them, and keep them. As long as that stone is fulfilling its mission of simply bringing someone a moment of awareness, I'm happy.

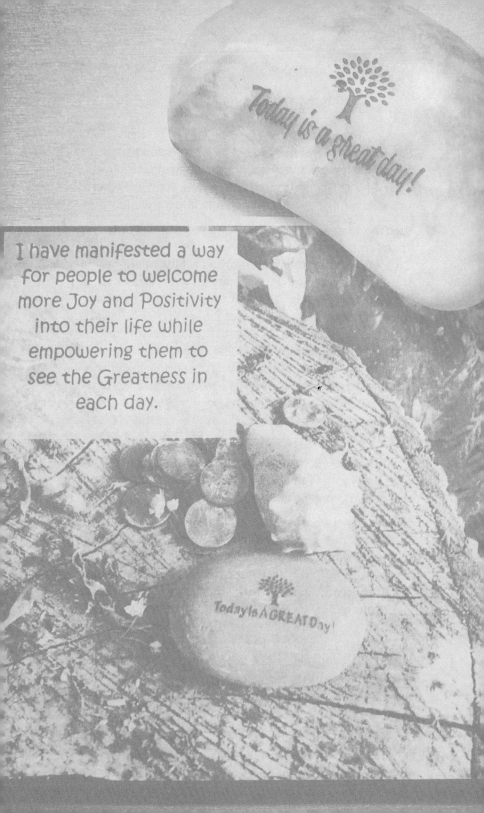

I have manifested a way for people to welcome more Joy and Positivity into their life while empowering them to see the Greatness in each day.

I spoke with Melisa who suggested I make a postcard around it for her project *Postcards to the Universe*, so, of course, I did. I wanted to expand the message as far as I could; it is a reminder to focus on what is good in our daily lives. Making a postcard helped me incorporate that.

Today, you can find the stones scattered across the globe! These little treasures are fulfilling a personal manifestation to spread joy, happiness, and empower people to see the greatness in each day.

You can follow the stones on my website sethbarker.com or on Instagram @greatday_365

Seth Barker

"Myriad—a vast quantity."

—Barry

Healing through Art

I have had HIV/AIDS for at least thirty-four years, and the creation of art has given me strength and the will to follow my passions and goals in thought-provoking representational art, life, psychology, health, and beyond. Art has been my source of healing. My passion for my craft has kept me going and kept me inspired. Some days, it is the only thing I have that gets me motivated. So I wanted to create a postcard for Melisa's project, *Postcards to the Universe*, around art and how it's been my source of healing. I knew exactly what piece to use and what affirmative word I wanted to use—*myriad*. It is all-inclusive and encompasses vast numbers. Perfect.

In a world where the rate of motion accelerates beyond comprehension, where immediate gratification is a priority, we lose the connection of the energies that the Universe provides us. A *myriad* of messages of spirit and vigor are essential for our growth to experience the essence of the here and now, and wander into the cascades of all interiors that guide us to all exteriors. We forget that the tentacles, the veins of conductivity, are the source of origination. There is no singularity, only a vast supply of coordinates and harmonization. Interconnection nourishes all complexities.

Soaring the Universe, assimilating energies, and creating works of art takes on a whole new meaning when we merge into and over horizons. Risk, challenge, change, and experimentation becomes the norm, and adventure penetrates while we become not only observers, but revolutionaries. This is the significance of the process of an initial concept of a work of art, and this process forges through the mind as we capture and clutch onto the creation of imagination. It's then that we ascend toward deliberation and the creative process has begun.

Life and health are one and the same—the connection is explicit. As in life, we don't acknowledge situations until the brain somehow chronicles them and their synergy is brought forth. One minute, we're living healthy active lives, the next, we're sick and in despair, and the next, through wisdom and knowledge, we can be able-bodied once again. My observance is exactly that through imagination and creation, making art is the balance I receive, which literally advocates my health. Contemplation of a new creation sometimes takes years to penetrate, then something pricks our mind, and the process begins. We develop the abstraction, which ignites into the theory and imagery, which takes a bit of time to perpetuate. The techniques are then available and interact with the expression. Line, balance, color, textures all contribute to deliverance. The passion, time, and persistence have now connected, and the child is born.

The Hollow Grave

The silhouette of a figure looms across a
Hollow grave
Its auras pigment the complexion of
Consciousness
Vapors suggesting an illumination of cosmic
Force
A divergence unequivocally comprehensible
But unwilling
Mist turns to breathe existence at The Rubicon
Choice of one's fate free will the moment of truth
Possessed by passion encompassed through the
Senses
Determination to evade deceit
The naked truth
A canvas alive incomplete and mysterious—
awaiting discovery.

Barry M. Gross

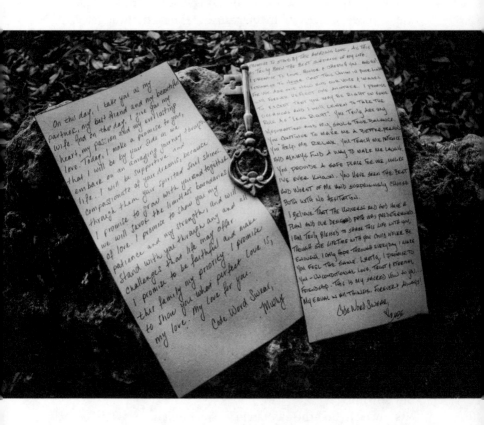

"Code word swear."

—Kim

The Power of the Universe

My early twenties were devoted to work and ultimately my career in law enforcement. While most of my friends traveled the road to their happily-ever-after and started families, I was so focused on being successful in this male-dominated field that my personal relationships took a back seat. During those years, I experienced multiple failed attempts at a happily-ever-after.

By 2006, after another failed attempt, I took a complete holiday, swearing off love.

In November of 2007, my friend, Melisa, thought it would be fun to celebrate my birthday by going to a psychic and then dinner afterwards. It was this moment that changed my life; however, I did not know it yet. Being a skeptic, I wasn't truly sold on the fortuneteller thing. I always thought it was a fun pastime for laughs…but never truly believed in their generic lines.

So, during my thirty-minute reading, the psychic, Ann, tells me the reasons for my past failed romances, a conversation which sounded like a good pep talk from a loyal friend. Then I ask the curious question, "When will I find true love?"

Ann replied with, "I see you with John. He's a strong man, about 6′3″, in uniform, loved by everyone."

My eyes sparkled at the thought. So I asked, "When, where, and how will I meet him?"

Ann smiles and tells me I already know him. I sat there racking my brain, "Who's John? Do I even know a John?" No one came to mind. She went on to ask me if I had any kids. I replied, "no." In my mind I was still too young, not at the place for kids yet.

I remember Ann looking up as if at the ceiling and saying, "Well, there's a child waiting to come in."

I smirked thinking, *Ha! Okay.* But, in my vision, I still had to find the perfect guy, get courted for a little while, be engaged, then married a few years before I would even *think* of starting a family. I had a plan. By my calculations, I still had a good four years to go before having a baby. So, naturally, I laughed it off.

Ann said, "He's waiting to come in and he's a golden child. They're rare; they only come around like every five years." Again, laughing it off in my mind, as I clearly chalked this up to mumbo-jumbo.

So, January 2008 came around. Still no sign of John, and honestly, I had kind of forgotten about our reading by this point. One night, I was working a detail, and hanging out with one of the other police officers named Eric. We're laughing and talking about all kinds of things—from childhood upbringing to favorite foods. Though we've worked together for several years, we've never really got to know each other. Turns out we lived close by each other, and ended up becoming good friends. Now, on a side note, I was always against dating someone I worked with. My philosophy was I'd be in the job longer than the relationship, so I never wanted to mix the two. So, as more time went by, the more I realized I had so much in common with Eric. But, I have my stupid rule, so I never thought of crossing the friend-line. I even told Melisa how great he is, but I just didn't want to date someone I worked with.

In March, Eric and I met for lunch; we chatted as usual. Then, for some reason, I thought back and remembered that years before I thought I heard someone call him by a different name. When I asked him about it, he told me his real name is *John,* but he's always gone by his middle name, Eric. At that moment, I felt the sun, moon, and stars align.

Oh, did I mention Eric was 6'4" in uniform, and one of those guys who's just loved by everyone? We started dating almost immediately. We were living together by May, and, surprise, surprise, I became pregnant shortly thereafter. By January 2009, we were truly blessed with our golden child, Keaton Thomas.

Our life is full of laughter and support. We try to remember, even through tough times, we're always on the same team. It's funny when you think you have your life mapped out or think you know how it's all going to go, the Universe seems to give you the path to what you need. Maybe even better than you originally expected it.

Almost eleven years later, I wouldn't change a thing. This life is still my cartoon land, thank you John Eric and Keaton Thomas for loving me. I'm forever yours...*code word swear!*

Thank you, Melisa, for bringing me that day and asking me to create a postcard for your project *Postcards to the Universe,* which turned into our love letter and our vows to each other.

Kim Windell

"I always dreamed of creating a loving group home."

—Teresa

For My Daughter

In my lifetime of seventy years and counting, I always felt that someday, some way, my prayers and wishes would come true. I tried very hard never to give up my hopes and dreams, even though there were many times I felt hopeless and wanted to give up. Times I felt there was no light at the end of the tunnel, and would think, *How do I find the strength to continue on? How do I raise a special-needs daughter who has multiple health issues and behaviors as well?* Her diagnosis is developmental disabilities with a mental capacity of a child. There are many quotes and sayings you hear or read that say, "Once you give up, you've failed," or "Your hardest times often lead to the greatest moments of your life." My favorite saying always was, "Your toughest situations build strong people in the end."

Every day, I would pray to the Universe to help me find a way to help my daughter. The daily struggles of simply getting through life were almost intolerable. As she became an adult, it became harder for me to continue to take care of her. I needed to find a home for her to live, but how do you give your special daughter to someone other than her mother to care for her, to live in another place? This just couldn't happen, what kind of a mother would that make me? I wished and prayed that I could find a way for us to continue living together, and for me to stay strong. My prayers to the Universe were to help me find an answer and to never give up. Every day, I dreamed of a home for her with good people to care for her needs, with love and understanding. But how was I going to achieve that? I had no idea, no plan, very little money, just hope and a prayer.

I had already created Rainbow Guardian, Inc., a non-profit charity to help the special-needs population. One day, never expecting this gift, my dream was just dropped in my lap. A beautiful, five-bedroom home in an area I love—close to my own home—just appeared. My daughter and son-in-

"Imagination is everything. It is the preview of life's coming attractions."

—Albert Einstein

law had rented this investment home for some time. They decided it would be great for my charity to take it and make it a beautiful home for my special-needs daughter and people like her. At first, I couldn't believe this came to me, and I was in shock and very scared to take this on. At that moment, my daughter said to me, "Mom, you always wished for this, so take it and thank the Universe for it, because it was meant for you to do this. Remember the old saying, 'Be careful what you wish for, it just might come true.' "

Rainbow Guardian Ranch opened on my birthday. It's our home for special-needs young adults. It is a happy home, filled with love and compassion; my special daughter loves her home and her friends who live there. She has a fulfilled life with lots of love, nurturing, and happiness. So, my story is that I have seen the pot of gold at the end of my rainbow, and the Universe answered my wish. Never give up hope, it will come, and sometimes, in ways you didn't expect. Always wish on that falling star, because what you give will come back—that is just the law of nature and the rules of the Universe. This postcard is my vision manifested.

Teresa

"What's your elephant?"

—Niki

Uncovering the Elephant

Growing up, I hated to be different. Born a Christian, I attended kindergarten dressed in regular clothes. By the time I entered first grade, my mom converted to Islam, and that meant I had to wear Muslim clothing, i.e., long dresses and head coverings. Thereafter, I was teased a lot, being the only practicing Muslim in my elementary school.

As my mom's religious fervor grew exponentially during her association with this particular Islamic group, there was also a hardship created for her family. She then moved us into this group's separate and insular living community, believing it would facilitate her new religious way of life. Only later to find out, the hard way, it was a cult.

During my time in the cult, we were groomed to be religious and blindly follow its leader. Through his diabolical teachings and control, we were conditioned to feel a false sense of protection—that when the world was destroyed, we, as the chosen ones, would survive and prepare for the second coming of Jesus. So, although we endured many forms of abuse and traumas within the confines of this community, we were protected from the purported greater harms of the outside world.

In this cult, control was kept over everyone through separation. Men were separated from the women, the children from the parents, and the boys from the girls. Additional subgroups were made by age. Throughout, room workers were assigned to oversee these groups.

Being eleven years old when we first moved into the community, and exposed to a regular life with family, the adjustment was alien and hard. I cried daily. I hated being the only child in the building who would cry for her grandmother. The other children growing up there didn't have a concept of grandmother and family. I struggled to fit in. I struggled not to cry at the various beatings we endured.

Too young to have a say in my life, and too old to forget my family, my tears went unanswered. Eventually, my only refuge was to turn inward and express my pain through my writings and drawings, with images such as pictures of eyes crying into an ocean.

By age thirteen, I was chosen to be around the cult's leader. At the time, he also became my father, as my mom became one of his many wives. Although I was his stepdaughter by way of marriage, my new father persisted in convincing me I was his actual blood daughter. As if this wasn't twisted enough to a teenager, he then also started molesting me, along with other young girls.

I endured the unendurable for years. Then finally, at twenty-five, I couldn't take it anymore. Why were we living in a supposed holy land, yet I was so miserable on the inside? Why were we promised so many things, for so many years, and nothing came to fruition? Even with all the brainwashing, none of it made sense to me.

Throughout my questioning, a little voice inside was scared of what could happen if I wanted to leave, yet I was too miserable to stay. I remember discovering a Reba McEntire song, "Is There Life Out There," and I wondered. Though I knew the fate of being unprotected if I left, I took the plunge and left.

I was scared. I had nothing to my name. No education past the ninth grade, as we had been taken out of school early. I believed I would be destroyed in the outside world, yet that was better than being stagnant where I was.

It was as if I was reborn. Years of an insular cult life had to be undone. Life on the outside was scary and different. There were lots of adjustments, that still to this day I am challenged with. But I found the inner strength to fit in with the outside world, and move on with life. I earned a GED and eventually put myself through college. Although I had

no formal training or a graphic design degree, I also started to evolve into the life of an artist.

Within the years following this horrific cult life experience, I became one of the key victim witnesses in the largest child molestation case in the history of the United States. For this role, I was awarded the highest civilian humanitarian award given by the FBI. Yet to this day, I am a target of current cult members who do everything and anything to protect their leader.

Thirteen years after I left the cult, I was doing a short online typography course, and something came over me. I went through pages of tracing paper, hand-painting words that just flowed through me. *Can they hear me? I prayed—why won't they save me? You could have left me with my crayons. I was chosen. It won't wash out; I don't want to be special. Where are my crayons? Why, Why! The lamb washed in my blood. Savior? No longer silent!* These were just some of the words that came out. I just looked in awe. I didn't intend to write them. Now that these words were out, what could I do with them? Eventually, I created a mixed media sculpture to go along with those words and the project, *What's Your Elephant,* was born. Thereafter, I started to develop other works and share my story as a sexual abuse survivor.

What's Your Elephant is now a movement that creates a safe space for people to use the arts to have dialogue and bring awareness to the unspoken. It includes visual and performing arts, interactive arts, creative community building, hands-on projects, workshops, and events. Through this movement, I have been able to share some of my stories, as well as invite other artists and workshop attendees to share their stories. This project has been empowering, affirming, and healing to all who have participated, both artists and attendees. Creating this postcard in Melisa's workshop *Postcards to the Universe* helped solidify this movement.

The intention behind this work is to not only share a personal elephant, but to have discussions surrounding unspoken topics, including the following: abuse, survivors of abuse, awareness, the power of a share and how the arts can be used to heal, empower, and educate.

It's about acknowledging the elephant and owning it, so that it doesn't define you. All my life, I struggled to fit in, and not be so different or an oddball. My journey has led me to embrace my unique gift as a survivor and artist, to let go of resentments and the shame of my past, and to use my stories through the arts to heal myself and others. I'm not at the finish line. Rather, it is a journey that I embrace each day, as I learn and grow. I have found power in realizing and embracing the fact, I am the *Elephant* and I am here to help change the world!

Niki Lopez

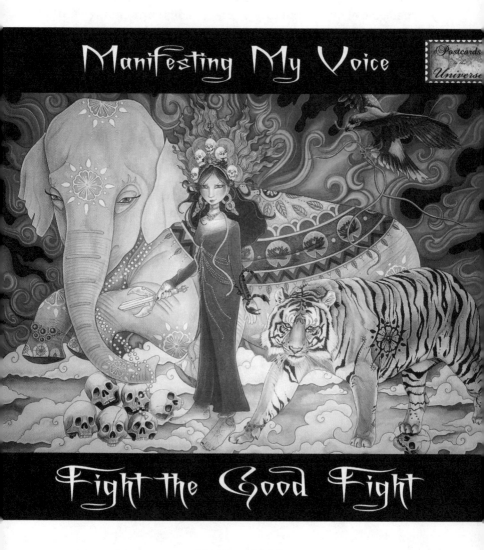

"Fight the good fight."

—Mary

Manifesting My Voice

Once upon a time, I found myself starting over. Despite the ads on television and the mantras on Facebook, there is no one-size-fits-all road map and cure-all to starting over. So, where and how does one begin? Drawing is my refuge. But it took two years of creating *cute* and *happy* drawings for me to realize I was still trapped trying to be someone else. I needed to find my voice, to tell my stories and to be heard.

This desire to be heard manifested itself in my very first alter-ego drawing, *Beauty & the Beast.* Beauty represents the way society wants us to be, especially women—silent, accepting, and non-challenging. The Beast is the way we often feel inside—angry, hurt, and screaming to be heard. These characters are two aspects of the same person. By creating the *Beauty & the Beast* drawing, I began the journey to unearthing or manifesting my voice.

In my first fairy tale inspired drawings, the women were silent, and their companions actively giving voice to what I was finding so hard to express out loud myself. But, as the women in my drawings began to speak for themselves, so did I. This newly found voice manifested into the *Goddess Series* I am presently creating. My first Goddess drawing was, *Fight the Good Fight,* where the Goddess, although not starting the fight, is ready to fight when necessary. Through the process of research, trial-and-error, and perseverance, I have begun to create strong, loving, challenging, and warrior-like women ready to help manifest strength, courage, and the willingness to fight for what I believe. These stories are mine. I claim them. I am not silent and refuse to be again. Thank you, *Postcards to the Universe.*

Mary Pohlmann

"And so it begins."

—Robby

And So, It Begins

Once you decide to live your life with passion and vision, it's almost as if you spread your wings and the Universe allows you to fly. Some say that believing in yourself is *magic* and once you can do that, you can do *anything*.

I'm a small-town boy—raised very simply to always be humble and content. But I've always had big dreams for myself and for life in general. Even though I embrace the spirit of contentment, and am truly thankful for everything, I have always known I was meant for something more. "A servant's heart," I should say. I want to be so passionate about life that it will bring joy to others.

When I first moved to the city I am in now, I was working three jobs at once to make ends meet, leaving little, if any, time to find passion and enjoyment for life. I decided to enroll in the local trade school to become a licensed aesthetician. I felt I could bring happiness to others and do well in the industry, since at this time, there were very few male aestheticians—giving me an instant upper hand.

After graduation, I was more determined than ever, and continued to work two to three jobs until I could build up my clientele enough to have just the one job. The hard work paid off, and after two years, I was able to become an established aesthetician with a following. After four years, I was able to open my own day spa. Things were looking up, but I still had aspirations of finding that *aha* moment. I auditioned for a movie being filmed locally. I had never done anything like this before, so I was very nervous, but the thought of it thrilled me. I showed up for the auditions with hundreds of other hopefuls. Thankfully, my audition process was humorous, allowing me to relax a little. I received an email a few days later, offering me a supporting role that filled my soul with excitement. This role led me down a path of other opportunities for film, educational

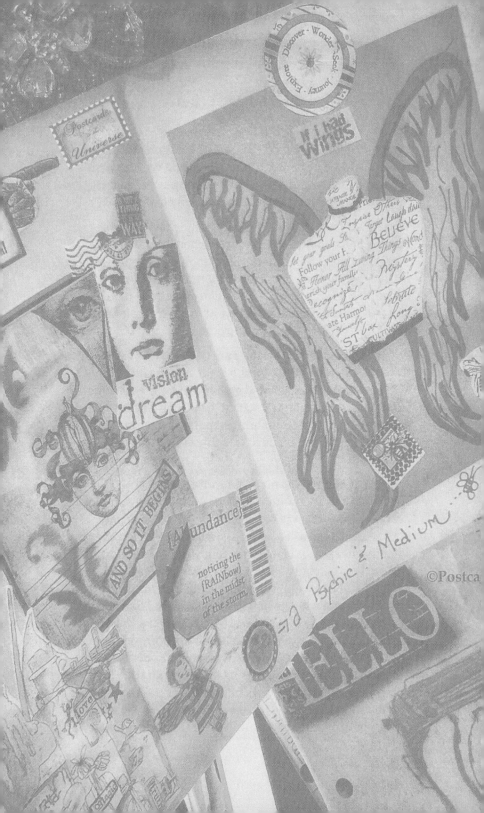

videos, and television commercials, and eventually, to the local civic theatre where I had so much fun.

When I came across Melisa's *Postcards to the Universe,* I instantly thought it sounded genius and fun. I got busy right away, crafting postcards with stacks of magazines in hand; I started cutting out any and every picture that spoke to my soul, allowing me to manifest even more hopes, dreams, and passion. I was so excited to get the card in the mail and put it out into the Universe as soon as possible, that I forgot to put a postage stamp on it. Once I realized what I had done, I turned my car around and went back to the post office. Since it was almost time for mail pickup, I decided to wait on the postman and beg him to let me dig through the letters so that I could stamp mine, but rules wouldn't allow. The Universe must have heard me because just a few days later, I received a message from Melisa that she had received the card even without the stamp required.

I put so many positive thoughts and energy into making my postcard, and the Universe was definitely paying attention. But once things were set in motion, I was a bit scared, almost like a tornado hit me, and I knew I was in for a wild ride. I decided to close my established business and go to work for another salon with like-minded people, allowing me more freedom to set my schedule and follow my passions. Business is booming, and now that I have more time to paint and draw, my paintings are selling fast. I'm setting up booths at festivals, mailing them out for online sales, and even thinking of dusting off my writing skills to finish a book that I started years ago. My spiritual gifts are an ongoing educational journey that I am loving. With manifesting magic, everything is coming together, allowing me to live my life with passion, vision, and discovery. I am finally soaring, and I don't ever want to stop flying.

Robby Allen

"Life is magic if you follow your intuition."

—Eliane

Creating Visions

My goal as an artist is to create art that makes people look at the world in a different way. I decided to create my postcards for *Postcards to the Universe* by painting my affirmations on wood, declaring to the Universe, out loud, "Yes, I am a thriving artist!"

I always choose to present my work in strong, bold colors, with an overall reliance on lines and forms to give it its distinctive nature. Through the use of these colors and forms, the subject is transformed into its essential formative concepts—both of simple and complex nature.

Life is *magic*, if you follow your intuition. Listen to your heart and make your choices with confidence. We already know that the Universe conspires when we have the energy aligned and in tune. I stand here fully present and trust my intuition. There are messages every day for us to be happier.

Creating visions on canvas is a sense of relief for me. It allows me to interpret my feelings and share them with the world. My body of work communicates energy and mystery. Composing is the focus point of my painting, and the final result of a work is due entirely to how it composed itself.

My new artwork series is bright, colorful, spontaneous, and happy; it showcases the shadows, light and movement, imitating the circle of life. Love, compassion, happiness, and dark moments all come together to create an unforgettable visual experience.

I always choose to present my work in strong, bold colors, with an overall reliance on lines and forms to give it its distinctive nature. Through the use of these colors and forms, the subject is transformed into its essential, formative concepts, both of simple and complex nature.

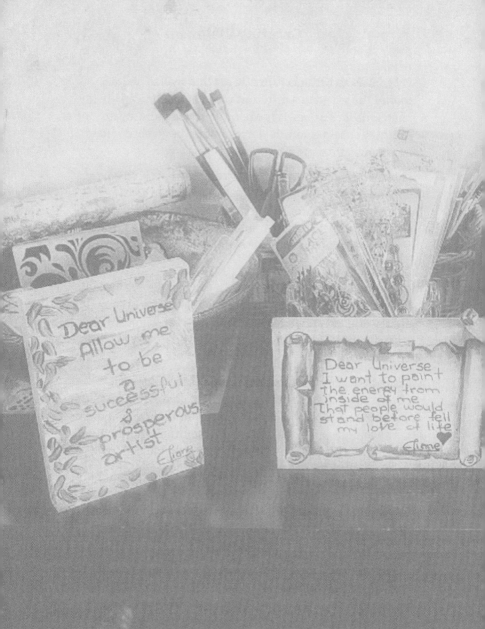

Being an artist is not just about what happens when you are in the studio. The way you live, the people you choose to love, the way you love them, the way you vote, and the words that come out of your mouth will also become the raw material for the art you make.

Eliane Harvey

"Ready, set—go beyond."

—Jordana

I Am Manifesting My Best Life

Ever since I can remember, I've always wanted to be a motivational speaker like Tony Robbins, and have my own TV talk show like Oprah Winfrey to help motivate people to live their best life. It pumps me up! You see, I've been a writer since I was a little girl, writing in journals, creating quotes that focus on gratitude and self-discovery, and saving images to inspire me.

Wherever I go, people seem to be drawn to me, and feel very comfortable to confide in me about their lives and goals. It just so happens that they are in need of some motivation when they come across my path. Coincidence? I think not. Young or old, it doesn't matter. We all need to feel supported and encouraged and that can come from a warm smile, a listening ear, or an inspiring word. I feel it's my calling to lift people up, give them a push in the right direction, and help them feel worthy to step into their greatness. It's very fulfilling.

When my youngest son was approaching freshman year at college, I was not looking forward to him leaving and having our once bustling home become unusually quiet. While I was excited for his new opportunities and experiences, for the past twenty years, I was a very hands-on mom to my two amazing sons. This was an uncharted and unwelcome territory. My oldest son was starting his junior year in college, and he was doing great!

While I've always empowered people on a small scale, I realized that I needed to coach myself for my next journey and jump into what had been calling me for a long time. I strongly believe in the Law of Attraction, in regard to attracting people, things, and situations. Manifesting what you desire through vision boards or *Postcards to the Universe* and taking action helps us achieve our goals.

I started a vision board/postcard several months ago and put on that board several things I wanted to attract in my life: a microphone for motivational speaking with my new business, *Ready Set Go Beyond,* which is already happening. I was honored to be guest speaker at a chamber of commerce women's event. I used a photo of a bookstore and book for my bestselling, empowerment book that's in the works; a photo of a large audience, representing future empowerment conferences I will speak at. I also included images of Europe, because I plan to travel the world motivating others, and teaching the benefits of a positive mindset and gratitude, like the gratefulness I feel every day for my amazing family, close friends, and beautiful life.

When I dropped my son at school for summer session, I decided I was ready to stop playing small, and I was ready to go all-in to be a mindset coach and motivational speaker. I was looking for a platform to reach more people and connect with them on a larger scale. I didn't know what that would look like. But I believed it would happen. I could see it. I knew I had a message that would impact people in a positive way, and they needed to hear it. *How would it get out there?* I kept writing and manifesting with images.

I saw myself reaching a lot of people on stage, with radio and TV. Shortly after, I was a guest on a radio/live-stream talk show; they invited me to come on set to talk and share about mindset and new beginnings as an empty nester. It went really well. I was so nervous; I kept thinking, *What am I doing?* I encourage everyone to explore something new—to see who you really are, what you're passionate about, and to then go do that.

One appearance led to the next, and they asked if I wanted to host my own show. That was so outside of my comfort zone. With lots of responsibility and commitment to find clients and sponsors, and investment of time and money, if I gave myself another minute to think, I would have rationalized and talked myself out of it. But, I'm so glad I

jumped in and said, "Yes!" It's been incredible! There has been so much growth and learning.

I have my own show called *Go Beyond*. I love what I'm doing, the conversations I'm having, and the lives I'm changing. I can't wait to see all the other amazing things I'm manifesting come to fruition for the future. Television, radio, keynote speaking events, empowerment conferences, book signings, and traveling the world with my family—enjoying the journey, continuing to help people live their best life, and to stop limiting themselves so they can to spread the power of positivity.

Jordana Foster

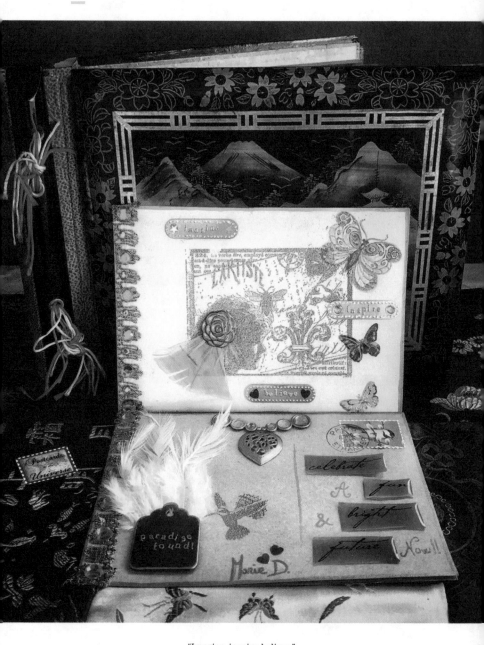

"Imagine, inspire, believe."

—Marie

Trusting My Intuition

A few years ago, as I was persevering in my quest to break through as a professional artist, my life took an unpleasant turn. With the economy crashing, along with both a weak financial and *faith* backbone, I was drowning. Within the same time period, one of my best friends, who was dying of cancer, would spend the last three months of her life in my home where she would dim her light peacefully. Shortly thereafter, a significant car accident would leave me without a car for two years, and eventually, I would also have to let go of my house. My life was in total disarray.

Then, one day, as I was desperately looking for a new place to live in and to pursue my art, a friend of mine mentioned the Sailboat Bend Artist Lofts in Fort Lauderdale. One evening, I attended an art exhibition opening and this was when I met Melisa Caprio. She was promoting her *Postcards to the Universe* project. I took three of her postcards and sent my wishes. After the first one, I was to be able to move into a beautiful, creative space in the Sailboat Bend Community so that I could pursue my art again. About two years and some months later, after sleeping on a twin-size day bed in my friend's home office, I was finally moving in and was able to go back to my passion and resume my quest of becoming an independent, professional artist.

My second wish was to reconnect with joy in my heart and soul, so that I could flow freely and harmoniously with my life.

Birds have always been messengers of God to me. One day, a little bird flew inside my loft, but stayed trapped for half a day. Even though all doors and windows were open, every time he tried to get out, he was stopped by the fixed portion of the windows. He could not seem to find his way out and was going from moments of panic to total apathy, perching high on one of my vases and staring at the window. At the

time, I had recently moved into my new apartment and was working at a full-time job, which was not a good fit for me and was making me feel miserable. Every passing day was getting worse, and I would come home in the evening crying, desperate to find joy and happiness in my life, and have the time and energy to create art and enjoy my beautiful apartment. Suddenly, it hit me like a ton of bricks. The message was so clear: I was like the little bird, trapped in a prison of my own imagination and creation, and all I had to do was look at my life from a different angle and realize I could make a different choice.

The bird eventually got out, but a couple of days later, it flew into my window again and died. I knew I was not going to die, literally, but understood that is how my heart was feeling...*lifeless*. I also realized that I had been banging my head against the wall over and over again, not being able to stand back and reassess my situation from a different perspective.

About a week later, I took a giant leap of faith and mastered the courage to quit my job. It was scary and my biggest fear was to run out of money and have to start over again, even more desperate than before. Along the way, miracles started to show up, and month after month, the Universe kept providing what I needed in many different ways in order for me to stay in my loft and to focus on my art. Slowly, my heart was beginning to heal and feel some joy again. Little did I know that later on my creativity would lead me to develop an *Intuitive Painting Workshop*, where I would guide people to connect to their heart and access their inner wisdom and joy. I once read, "We only teach what we also need to learn."

My third vision was to use the energy of transformation of the butterfly to allow me to delve deeper into my soul and to bring my creativity to new heights that it had never reached before. About a year after moving into my new apartment, I received the inspired vision of painting a

series called, *I AM…*, where each painting's purpose would be to capture the essence of all the powerful emotions we need to cultivate in order to manifest our dreams into reality and thrive in our lives. I realize now, it is an endless work in progress that cannot be rushed. I am learning to relax more, trust the process, and tap into the emotions and feelings of love, light, peace, abundance, joy, gratitude, and more as I am guided to paint them.

I am now starting to enjoy the fruits of my labor; my vision is expanding to manifest a larger creative space and an increase in sales to be more self-sufficient. This is just the beginning of my dreams. The best is yet to come. The Universe is working its magic behind the scenes at all times, but we need to do our part as well. Our desires and dreams are so powerful, but equally important are our intentions and emotions. They all have to be nurtured with unwavering faith and kept vibrating at a high frequency. It is a choice only we, as individuals, can make. Every day we have the power to decide and set clear intentions for the kind of day we want to experience, what we want to accomplish, and how we want to feel. To manifest a dream into reality takes courage, discipline, consistency, perseverance, and the ultimate realization that we have to accept the commitment to work on our deeper emotions for the long run. *Life is a journey, not a destination.*

Marie Donze

"Searching for Persephone."

—Carolyn

The Universe Has My Back

All I knew was Tara wanted to sing. At first, I didn't know her name, but I knew what she wanted. When she looked out to the limitless blue sea, she knew she did not want anyone to hold her back. She did want someone to hold her, someone who would wrap his arms around her at night and hold her close. He could love her, and she could love him, but they would never own each other.

This is how the first glimmerings of my novel came to me, and this is my postcard for *Searching for Persephone*, which includes my first pitch to literary agents. Set in the Greek islands and in hurricane-ravaged New Orleans, the novel is richly textured with music, food, love and yearning. It is a reinterpretation of the Persephone myth, when the young Persephone is abducted to the underworld, the place of wildness, where we must face our unfulfilled yearnings and untapped passions, and we must harness them. In that myth, Persephone makes two yearly migrations: Each fall to the place of wildness, each spring to the place of belonging, where she is returned to her mother and the abundant earth. My thought in creating this tri-generational story is that when it comes to art, when it comes to love, when it comes to finding your voice, we need both places— the divergence into wildness, the return to relevance and constancy. We need room to explore—to search, each one of us, for Persephone.

This myth gave me the motif for what is a very contemporary novel that deconstructs what relationships are in our turbulent times. I also wanted to understand how a woman can have art *and* love, solitude *and* intimacy. I wanted to know how a woman allows her voice to emerge, strong and clear, in this world when we are still so afraid of what a woman in power might say, and I wanted to portray a woman who creates a loving partnership that thrives. This is both—a novel about women who lead bold and

illuminating lives that bust the paradigms of our time. In workshops during my MFA in writing program at Spalding University, fellow students found it subversive, but they never found it boring!

One of the most subversive themes of the novel is how it takes on the very underpinnings of marriage. I found marriage, as it is constructed in present day society, to be more of a legal and financial institution that, while it may create wealth and social status, is not attuned to creating a vibrant loving alliance that is fresh, alive, and breathing. It creates conformity, and at its worst, a prison. It suppresses the very thing that has attracted two people to each other. As the poet William Blake writes, "He who binds to himself a joy / Does the wingèd life destroy / But he who kisses the joy as it flies / Lives in eternity's sunrise." In my novel, Tara wanted to know, upon meeting a singer-songwriter who seems to see into her soul, if it was possible for two people to create that vision. What she doesn't know, until a long-held family secret is revealed, is that her grandmother and grandfather have already created the model and given her a living representation of what she wants.

At the time I created this postcard, I was preparing to pitch to six literary agents in New York. I wanted that moment of yearning—and all of the questions it unleashed—to be captured in a card so I could convey that to the agents. It was my act of intention. It worked! Six out of six agents asked for the full manuscript.

Since then, the novel has won a semifinalist prize and has undergone a revision. Its title now is *Our Year of Quiet Hunger.*

Because Melisa urged me to, I made this postcard. It has sealed me, quite sacramentally, to my intention. Writing and revising a novel is a long project, and this postcard for *Postcards to the Universe* has provided for me a focal point that has carried me through. As the co-author of

a book on creative visualization *The Complete Idiot's Guide to Creative Visualization*, I have practiced the art of marshaling all the loving energy of the Universe into hearing what I want, deep in my heart, and in response, trusting that the Universe has my back. Like Tara, I stand at the edge, and I sing.

Carolyn Flynn

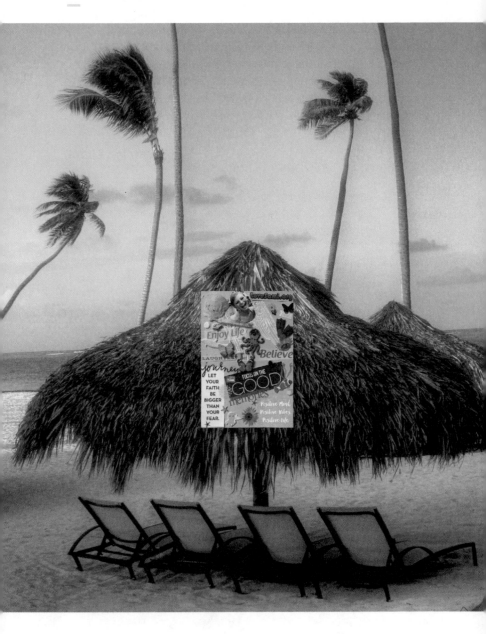

"Focus on the good—enjoy life."

—Dori

There Is Healing in Helping Others

I am a native Floridian, born in Boynton Beach in 1968.
When I was six months old, my parents divorced, and I was
left in the care of my paternal grandmother, Dorothy, whom
I was named after. My mom came back and visited me all
the time. I even went on many vacations with her while
she was going to medical school and working. I grew up
in a neighborhood, and in a time where kids could be kids
and could be left to their own devices. I was most often in
the woods climbing trees, usually with other neighborhood
kids. My grandmother, who was a saint in my eyes, could
never have known that a predator was lurking and soon to
strike. I was victimized at a very young age and never told
anyone...I later learned that I had repressed that horrible
memory. I was super happy and content being raised by
my grandmother who loved me like her own daughter,
and I was spoiled rotten. My grandmother and I went to
church together, and I would even *help* lay out the bread for
communion. We were both very involved in giving back to
our community. Often the priest of the Lutheran school I
attended would come over for dinner.

When I was in the third grade, my grandmother passed
away from cancer. I went to Miami to live with my mom.
It was not a happy time; I was being abused. When I was
fifteen, I could not handle it anymore, and all I could
think about was ending my life. I tried twice, and neither
attempt worked—I didn't know what I was doing, thankfully.
At seventeen, I moved out and was on my own. I became
estranged from my parents, and by twenty-three, I had
had enough of life again after being kidnapped, raped, and
beaten repeatedly. I decided I was really going to end my
life this time...and this time, I knew how. I took forty-six
muscle relaxers. I went into a cow pasture—far from any
place, so that I could just go to sleep and wake up in a
peaceful place. That is exactly what happened. I died that

day. I still to this day do not know who found me, but I am so grateful that I was found. I was so caught up in feeling sorry for myself, I never gave a second thought to everyone that loved me, and how me killing myself would have affected them.

From that moment forward, my life changed. I realized I had a place and a purpose here on Earth, and I was going to make it count. I started with reading workbooks to help me get to a better place, one filled with positivity that I would pass that on to others. I cannot tell you how many people I have given Louise Hay's book, *You Can Heal Your Life* to. This book was so instrumental to me. I went on to experience workshops with Wayne Dyer, Tony Robbins, and on and on—taking all the good that I could from all these amazing people and turning my life around.

Two marriages behind me and one beautiful daughter later, my father committed suicide in 2011. It was devastating...I just could not believe he actually did it. He had been telling me for years, but I never believed him. *Oh, the guilt!* I swept it under the covers and out of my mind, I just could not handle dwelling on it. I did not want my daughter to know what kind of legacy her grandfather left her. I was so damaged, I could not even read the letter he wrote to me to say goodbye.

All that changed when I met John in 2014. You see, John's daughter, Sami, committed suicide in 2014 when she was only nineteen. John and I had been talking on the phone for several months, but we had not met each other in person. When we finally did meet, it was crazy. I was so drawn to him. When I found out about what happened to his daughter, my heart broke for him. All I wanted to do was make him feel okay, help him, see him smile again. I had no idea how to do it, though, because I had only scratched the surface of the grief caused by my father's suicide. I started with making a phone call to Jackie Rosen of *FISP, The Florida Initiative for Suicide Prevention*. She had lost

her son twenty-two years before to suicide. You see, losing a child is very different than losing a parent or anyone else. She helped me so much; she gave me all sorts of guidance on how I could help John.

John and I read books together. We learned about all sorts of alternative healing therapies. I have always been an outdoorsy person and an animal lover. After I saw a private animal rescue in Miami, I took John there; I saw him truly smile for the first time while he fed a camel and a zebra. John would come home from work and tell me that he felt good, because he had spoken to someone at work that was going through a difficult time, and he helped them to feel better. It was getting close to Christmas; I wanted to do something really special to honor his love for Sami. I decided to make a memorial tribute website for him; I called it *LoveSami.org*. I was hoping that maybe one day he would want to do some healing work as a charity organization.

This is how *Love Sami* came into being. It truly was a work of manifestation. Wanting to make people feel better, get them out of their depression and struggles of grief over losing someone to suicide. Sadly, speaking about suicide oftentimes is a taboo subject, and it is highly stigmatized. Current statistics show that suicide is on the rise. Feelings of grief, loss, overwhelming sadness, depression, anger, and numerous other emotions take over the life of the survivor.

John and I have made it our mission through *Love Sami Organization* to bring healing and hope to those that have lost someone to suicide and to bring about awareness to the many individuals that face suicide risk. We are dedicated to suicide prevention, advocacy, and awareness—aiming to bring hope and joy to survivors of suicide. We work with veterans, police officers, firefighters, the LGBTQ+ community, and other demographics at high-risk of suicide.

We provide healing experiences, which have been shown to have a therapeutic effect on individuals. These include swimming with a baby tiger cub, learning to snorkel or dive in the ocean, swimming with dolphins, interacting with baby animals, horse therapy, paddle boarding, aquarium interactions, and so much more. There is never a charge to participants in our programs. It is our vision that not only will they experience the healing aspect, but they will also realize that life is worth living, beautiful, and meaningful. We have found that reaching out to these individuals has had a healing effect on both John and me. We want to be able to touch the lives of other survivors in a powerful, positive, healing way.

We have fundraising events on occasion and the proceeds raised are used to fund the trips and events for survivors, a billboard program, and we hope to be able to one day have a Love Sami Village where individuals can come and enjoy beautiful scenery, and lots of healing on-site, all at no cost.

I believe that John's daughter, Sami, and my father, Stuart, up in Heaven, brought John and I together to leave positive footprints here on earth—to help teach others the value in life, to teach others that life is short, so we should live in love, and enjoy it. This postcard for *Postcards to the Universe* is a representation of all that we have created.

Dori Liotta

"*National Geographic* dreams."

—Rick

The Photographer Dream

I was born an "army brat"—a term used to describe the children of military parents who relocate every few years for work. It meant making new friends quickly and seeing the world from a global perspective. Growing up in Japan and Greece, the ocean was my home. My favorite beach was complete with manta rays I could ride on and, one time, a Portuguese man-of-war that almost killed me.

My family retired to Gainesville, Florida. My father created an insurance company. I went from high school to the University of Florida. My grades were bad, but my job for the *Independent Florida Alligator* was spectacular. I photographed the presidential campaigns of Ronald Reagan, Jimmy Carter, all the football and basketball games, and the launch of the first space shuttle for United Press International. I won lots of awards, graduated with a degree in Political Science, and decided I wanted to either become Jacques Cousteau, or a photographer for *National Geographic.*

I had applied for the internship program at *National Geographic,* and out of 6,000 applications, I still thought I had a chance. The letter arrived and it read, "Thank you for your application. You placed third in our search, unfortunately, this year due to budget cuts, we are only able to have two interns." I was heartbroken as it was my senior year; I didn't have a second chance.

Fortunately, my two other choices, the *Minnesota Tribune* and the *Miami Herald* both made offers. Accepting the *Miami Herald* lead to a fifteen-year career, the first day of which was photographing the McDuffie Riots in Overtown. The last days were being a part of the Pulitzer Prize winning team, covering Hurricane Andrew. I even dove with Mel Fischer the day he found the *Atocha*, worth billions

of dollars, and located the first chest of silver coins in the wreck.

I met the love of my life, a writer for the *Miami Herald*, and we had two wonderful children together. Twenty-four-years into the marriage, she took a major job in NYC, and I stayed behind to see the children off, sell our two houses, and earn a Master of Fine Arts degree so I could teach at the university level in New York. After a lengthy job search, I landed a job on a Friday. Sunday brunch was met with, "I don't want you to move up here." The divorce was final at the twenty-seven-year-mark.

To say I was in shock would be an understatement. Until this day, I don't fully understand her declaration, "I just like living alone more than living with you!"

Thank God I had a wonderful job as a professor where I could pay forward the Universe and the good karma life had bestowed on me. I also knew that the unconditional love of my children had ultimately worked to get me through the hard times. After all, the phases of loss—denial and isolation, anger, bargaining, depression, acceptance—were familiar to me, having lost both of my parents in the few years leading up to divorce.

My sister-in-law had lived with me for a year after the divorce, along with my daughter. She and I compared notes from her divorce and talked about the dating world nightly. It was odd, but comforting to find out how to date. The last time I had dated there was no internet, and certainly no cell phones. A month after she moved out, she was diagnosed with cancer and died within two months. Watching her die, surrounded by her two teenage children and family, I grieved again and imagined being alone.

This is the head space I was in when I came to Melisa and her *Postcards to the Universe* workshop. To be honest, I saw her photo on Facebook and thought she was very pretty. I thought *I'll go and meet her*, or that I might meet someone

else who was at a similar space in life. When asked to make a postcard of my aspirations, I almost cried thinking about the scuba diver I used to be, achieving a thousand dives by the age of twenty-one. I only dove four times during my twenty-seven-year marriage, and wanted more than anything to be an adventurer and photographer for *National Geographic*. I had set aside my childhood dreams for a life I truly was blessed to have, but now had a chance to pick up again.

The next summer I taught in Kazan, Russia, in a Broward College initiative to bring our educational standards to Russia. This summer, I taught in Shanghai, China doing the same thing, followed by thirty-days of scuba diving on board a ship around Komodo Island, living on a private diving island called Wakatobi—finally diving the last days in Bali, where I experienced a 7.0 earthquake, and the renaissance moment of my life. I decided to post some of the photos to *National Geographic*'s, "Your Shot," and have had half a dozen mentions by the editors about the quality of my work. I'm in the process of getting an assignment with the magazine and starting over down the path of adventurer I had strayed from so many years ago. I've also met a few beautiful women whose presence in my life has been symbiotic, wonderful, and enriching for each of us. Many remain my friends; we all have become better because of our relationship. I remain true to myself. I have given love without condition. I have left everyone in my wake better off for having known me, and I am grateful to be a truly blessed man.

Rick McCawley

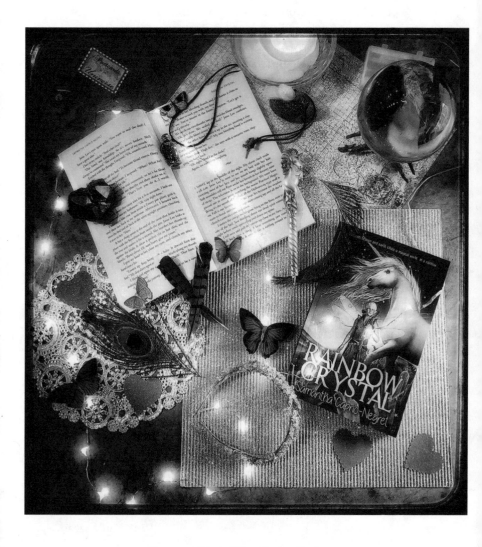

"I am a published children's book author."

—Samantha

Dreams Do Come True

When I was a child, at the innocent age of six, my favorite grandmother passed away. I didn't know how to process death. All I knew was I wanted my beloved grandmother back, and I wanted to feel her spirit. I didn't know how. I just wanted to connect with her again. I subconsciously found a way to do that. Soon after her death, I stumbled upon her booklet of poetry. I didn't know my grandmother was a writer. I read her material, and I felt like I was reading a famous poet's work. I was flabbergasted. It was like a mysterious secret about my grandmother unfolded right before my eyes. I wanted to be just like her—just like that! So, I bought a black-and-white notepad and pencil, and started writing my own short stories and poetry. Let me also mention, I was obsessed with rainbows; I would always be drawing and coloring them as a kid too. I had no idea why, then, but later on in life, it came back around full circle...all of it.

Fast forward to my early twenties, I didn't know what I wanted to major in until my father suggested I would be good in journalism. I never thought of it. I was lost and confused at the time about my passion, and he thought it would be good for me, because he knew I enjoyed writing and didn't mind being in front of a camera. I went for it... and I'm so glad I did. It turned out to be one of the best decisions of my life because it taught me the craft of telling a good story, how to be a better writer, how to listen and interview to make for a better storyteller, and how to perfect my grammar. After graduation, I had my heart set on becoming a journalist/broadcaster and interviewer. However, fate had other plans.

Months and months led into years, and I couldn't find my dream job. I resorted to bartending for a while after college to pay my bills, and I even took up traffic producing at one point. I hated it and was miserable. My living arrangements

and relationship hit a low and big turning point, and I
was forced to make personal decisions that affected my
professional ones. I decided not to move out of state, to
stay behind and support my fiancé. I didn't want to leave
him. My broadcast journalism dreams were put on the
back burner. Boy oh boy, I'm so glad they were. Everything
happening behind the scenes, I later learned, was all
part of a bigger plan. I was not meant to find a dream job
in journalism. Thank heavens for that, because as I see
journalism today, I do not have the backbone nor am I
meant for it.

During the rebuilding of our relationship and planning
of our wedding, I wanted to get back to my love of telling
stories and creative writing. During this time, I came up
with the idea of a humorous, animal-talking, chapter
book called, *Murphy: The Phat Cat*. It was based on the
inspiration of my real-life pet and black cat, Murphy, who
reached thirty-five pounds at one point. I've always had a
lot of pets—my family and I are animal lovers! I wondered
how my pets would sound if they could talk. What their
personalities would be like if they came to life on paper?

After writing *Murphy: The Phat Cat* as a book, I joined
SCBWI (Society of Children's Book Writers & Illustrators),
went to conferences, joined writers' critique groups, met
other children's book writers, did many revisions on the
manuscript, and realized it is what I wanted to do with my
life. It wasn't just a hobby anymore. It was my life's dream,
passion, and career path. I perfected it the best I could. I
submitted the book to hundreds of agents and publishers to
no avail—rejection after rejection; years of discouragement.
During those years, my best friend of seventeen years died
in a tragic accident at the ripe young age of twenty-eight.
I was in a dark place, and I needed to use writing as my
therapy. This story came to life inside of me, and I had to
tell it. This was my second children's book, although the

first was yet to be published. *Murphy: The Phat Cat* was meant to be put on hold for a little while.

Rainbow Crystal was manifested through my pain. It is a middle-grade, fantasy novel about a ten-year-old girl who loses her best friend in a tragic accident, and learns shortly thereafter that she is the chosen one to journey through a magical world inside a rainbow to return a powerful crystal back to its wizard owner, which was stolen by an evil witch and her trolls. It's a book about true friendship, grief, and finding hope again after loss. It's also a magical, adventurous book filled with mystical and mythical creatures. There's that rainbow I was talking about earlier. I colored them as a kid, now I was venturing through one in a book. *Wizard of Oz* was always a family favorite around our house. It all came back around, like I said earlier. Another finished book, years of writing, and more years of rejection, but I never stopped submitting and believing in my dreams.

I did the journaling. I wrote my dreams and manifestations down, including on the *Postcards to the Universe* postcards. I also created vision boards and did life coaching. I got knocked down over and over, but I continued to get back up. I wouldn't let it stop me. I kept saying it would happen, even in my darkest days when I doubted myself and was in a self-pitying party of despair. I never gave up. I just kept going. Failure was not an option. Then, one day, it just happened. I got that letter from my publisher. "We love your book. We want to publish it. Welcome to the family!" It was one of my deepest and greatest dreams come true! It didn't happen overnight, and it definitely didn't happen in the way that I thought it would, but it happened in the way and in the time that it was meant to. It all unfolded divinely perfect. I manifested it, because I didn't stop working for, believing, and visualizing it. I also believe in more and even *bigger* dreams and blessings to come. I'm just getting started.

Rainbow Crystal was released on May 15, 2018. The book cover art design came out more beautiful than I ever

envisioned, and my book-launch event was a dream come true! It was everything I ever envisioned and more. It was my personal gift of manifestation from the Universe. It was saying, "This is your purpose. This is why you're here. This is your present." Let me also mention that I received the publishing contract for *Rainbow Crystal* on the one-year anniversary of Murphy's death, and I signed the contract on my sister, Melisa's, birthday. Coincidence? I think not. All my dreams coming to fruition, and on the special dates that were meaningful to me, were only signs from the Universe that it was all meant to be and unfolding exactly the way that it was meant to.

Samantha Caprio-Negret

"I am falling in love with casa charm."

—Angelique

Falling in Love with Casa Charm

My father urged me to come visit a long-time neighbor of ours, Charmian, who was in a nearby senior home completing rehab after a bad fall that landed her in the hospital. I thought it was an odd request, but to placate my father, I figured, *What could it hurt?* I hadn't seen her in years, and it would be nice to catch up with him.

I was living in Lincoln Park, a posh neighborhood in Chicago in a Victorian flat that I loved. It was beautiful, although it hadn't started that way. I had begun painting it, with owner-approved colors and refinishing the wood, as the paint had been peeling. I was planning on leaving my husband, and I needed a quick getaway. I felt it would be a good investment, as I planned to stay there a while.

When I arrived to visit my dad and my former neighbor, I was surprised at how dour the mood was. It seemed that the senior home was refusing to release her to her home. I was outraged. It seemed like senior abuse to me, and as a fighter for the underdog, I got involved. I called a lawyer friend of mine to investigate the proceedings. I suspected that they were attempting some underhanded shenanigans.

Once the court proceedings began, my dad volunteered to be Charmain's guardian, even though he was just five years younger. My lawyer friend, who ultimately took the case, said that was not unusual, but he was concerned about who was going to do the work. My father could barely take care of himself, let alone a ninety-two-year-old woman. My father had been assisting her for the past few years, but now we were talking coordinating full-time care and paying her bills after taking over her finances. Charmain would have to agree to this, and she was very hesitant, because she had been an independent woman for most of her life. I was also hesitant, since I realized the amount of responsibility that was involved. My father, in a very emotional appeal,

said to me, "Angelique, I have never asked you for anything. Please—we have to help her. What this senior home is doing is wrong and she has no one else." It was true; she hadn't had anyone for years. Her mom had died at ninety-five back in 1992. As an only child, she had been alone a long time.

Charmian, Charm for short, had a personality that was lively and young at heart. She had been the celebrity in our neighborhood, and was known as Elvis's aunt. A 1977 El Dorado Cadillac was parked in her driveway, and it had the initials EAP placed on the driver's side door. If you didn't recognize them, it stood for Elvis Aaron Presley. She was the president of a local fan club and had visited Graceland many times. It wasn't until after I became her guardian and she had passed away that I remembered an event that had taken place when I was thirteen years old—in 1977.

My mom, sister, and I had been taking a walk to see the neighborhood, as my parents had just purchased a home there. Charm and her mom had lived just five doors down on the corner lot. The house was very different from the rest of our neighborhood of craftsman bungalows. Her house was dainty; it was a mid-century ranch with pink and white trim. I saw this tall, glamorous woman, dressed à la Audrey Hepburn, with plaid cigarette pants, a sleeveless ivory top and short white gloves—topped off with a large-brimmed straw hat, pruning her rose garden. I thought in my mind, *I want to be like her, very glamorous. I really like this house...I would like to live here one day.*

The Universe conspired to help me become the owner of the house. After my divorce that resulted in total financial ruin, I had to fix my credit. I was aware of some constraints that led to a denial on a recent application for a home loan. I prayed to my mom, Charm, who had passed away by this time, and the house. I would even talk to the house, and say, "I would like to be here with you and take care of you, but you have to work some magic to get me that loan." After six months of back-and-forth with the mortgage company,

and jumping through numerous hoops, I was approved
for a loan for the selling price of the house. The estate's
lawyer had been skeptical about pursuing a petition to
purchase the house; she said, "It is very rare to approve the
administrator of the will for permission to purchase the
house." But the mortgage company and the courts approved
me—no small feat. After a year of this, and creating my
postcard for *Postcards to the Universe,* I currently live in her
house, a house that she loved very much. I am the caretaker
for this little palace, one that I inhabited in my dreams as
a child. I was not so bold to believe that I could ever live in
such a place, but to me, it is my palace, a kingdom of sorts.

Angelique Metroyer

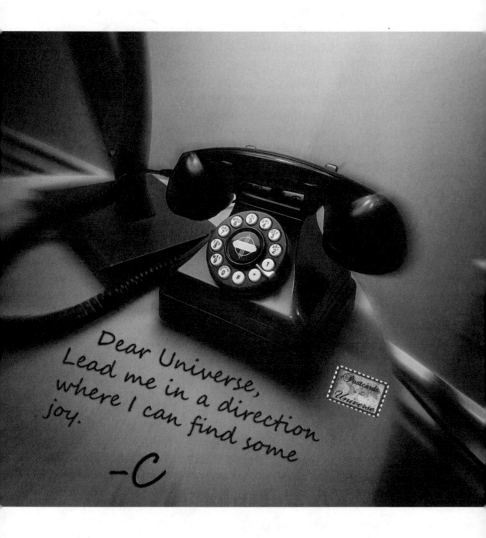

"Lead me in a direction where I can find some joy."

—C

A Change of Heart

I grew up in a house of lawyers. Both my grandfather and father were attorneys, so it was expected and assumed I would follow suit, which I did very unhappily, and I kept that unhappiness hidden deep inside. Part of the reason was because I didn't want to upset the family, especially my father. It was drilled into me since I was a very small boy. The other part of the reason was because when I had started university, I still had no idea what else I would want to do. So, I went along in the family tradition.

I became a defense attorney—a very successful defense attorney. I was making an excellent living at it, but inside, I hated every part of it. I couldn't stomach some of my clients who I knew were guilty of the crimes they were accused of. Yet, every person innocent or guilty is entitled to a fair trial, and my job was to defend them. Liking them was not part of the job description. I lived in a very nice flat, had a shiny sports car, went to fine restaurants and owned expensive suits. Inside, I was slowly dying. I would fantasize about living another life.

I was with a friend at an art exhibition in some very cool studios where artist's live and work, and I had been introduced to Melisa while she was sharing her project, *Postcards to the Universe*. She asked if I would like to grab a postcard and write down something I wanted to manifest in my life. I wasn't quite sure what that meant. But she had one picture in particular that I liked sitting on her table. It was of an old rotary telephone. It reminded me of my father's phone in his office when I was a little kid. I asked if I could write something on it. She said I could even though that wasn't one of her usual postcards, but just a photo she had printed out. I was struggling with what to write. I already had so much so she suggested I write something I want to feel. What came to me was, "Dear Universe, lead me in a direction where I can find some joy."

I left the postcard with her and went about my life. Fast forward two months later, and I was in my office preparing for a case when I collapsed and was rushed to the hospital. I had a heart attack. I was very lucky, according to the doctors, and while I was in the hospital recovering, I knew I had to change my life. I knew I couldn't do that job any longer. I told my family, and surprisingly, they were more supportive than I had thought they would be. I transferred all my cases to other attorneys and did nothing for a while. I was lucky; I had money to sustain me, but I needed to think about what I then wanted to do with my life. For the first time, I took care of myself. I started reading and taking classes and courses and trying new things that I had never had the time for. I really listened to my heart. I discovered that I liked sharing my knowledge with others, and I really wanted to help people, especially children. So, I got my teaching degree and became a teacher.

I sold my flat and my expensive car and moved into a very different neighborhood. I got a job at a school that I believe really needed me. The school had a high dropout and crime rate. I felt strongly pulled to reach these kids before they grew up and became a defendant sitting in a criminal attorney's office, preparing their legal defense for committing crimes. I knew I could help; this is where I could reach them.

It was the best decision I have ever made. My life has completely shifted, and I am so fulfilled. I know I am where I am supposed to be. Don't get me wrong, this job is very challenging and difficult at times, but I am making a difference. My student's success is my top priority, and I am seeing the influence I am making. This is what is bringing me so much joy. My salary is not nearly what it was when I was practicing law, but it doesn't matter. My life is so much richer.

I had forgotten about the postcard I made, until Melisa and I connected again and she reminded me that I had created

one. She asked for me to contribute my story to her bookand
I said, "Yes of course. I guess I got what I asked for." She
just laughed and shook her head. My only condition was to
remain anonymous for privacy purposes. I want to protect
my students, my old clients, and my family.

I don't know if making the postcard was the reason all of
this happened. I am very analytical and a bit skeptical
by nature, but I mean this, *I cannot count this out, and I
no longer believe in coincidences.* I believe I was meant
to meet Melisa and participate in her project, and I am so
grateful I did.

C

"I treat illness at the source."

—Sheri

The Healing Prescription

I never thought one day I would be known as "The Revitalizer." I am a healer now, serving others, after my own pursuit for healing for the past twenty-five years. I didn't have the confidence to own my abilities and gifts for over fifty years, until one day, I had a wakeup call!

Yes, a wakeup call—one of those moments when you just know, and feel it in every cell and ounce of your body. It was when Dr. John Demartini was speaking in a presentation in Miami, that I got blessed to get almost in the front row seats! When Dr. Demartini asked what our highest values were, and he went through his system, it was then that I realized that healing is my everything!

It is where I spend most of my time, money, vacations, conversations, environment, and it is all I think about. What do you talk to yourself about, what inspires you, what do you love to learn about? Look around you. What is it you can't live without? Once you live in your highest values, you begin to own your life.

I have been trying to stay alive holistically for almost thirty years without prescription medicine for an autoimmune disease. It has not been an easy or an affordable health challenge. I spent all my money and my time learning how to stay alive in body, mind, and spirit, as I believe they are one. I helped heal myself and others naturally.

I knew I had a calling inside of me that needed to come out, I just didn't have the power, confidence, determination, and the ability to follow through. As a Capricorn, once I make up my mind, I do it. I may give up if it is not right for me, but I have bought domains in the middle of the night, started meetups, and Facebook groups. Once I have an inspiration, I must follow through with it.

Sometimes, you have to jump and just do it. Many may feel like they are dying inside if they don't find their true calling or purpose, a reason to wake up every day, your *why* to live—to wake up and not feel trapped like a lion in a cage.

Once I owned that healing was everything to me, I pursued my Reiki Master Certification, finally, after fifteen years of putting it off. I believed I couldn't be a healer until I had my master's level. Who would want to pay me for my services? *What the hell do I know? And what would I charge? Who knows?*

Facebook changed my life. I posted my certification on Facebook and had over three hundred likes and comments; yes, I have a really good support system. These individuals wanted to know where and when they could have a session. *A session? Here we go!*

Hosting them at my house on Tuesdays and Thursdays, my sessions lasted two hours, and I was booked all day, every day, going forward. I had to move work out of my house, as my cat kept jumping on the treatment table during the session and interfered with people with allergies. I heard there was a room available in an acupuncture's office, so I went over and made arrangements to move in with a handshake and my first month's rent. That's all it took!

There was no looking back for me. So, my advice is to stop your procrastination and just do it! When you find your passion and are ready to awaken it, do not put out the fire of following your dream. That would be you giving up on yourself and denying others an opportunity to experience your gifts, skills, and talents that you were born to provide.

Yes, I have had bumps in the road along the way—moving four times in the first year, changing my marketing, financial challenges, depression, frustration, overwhelm, and the many emotions that entrepreneurs encounter. However, I never gave up.

I also started a weekly meet-up called Revitalizing Tuesday that has been running since June 2005. This gathering brings together a conscious community of healers and light workers, energy healers, mediums, psychics, and more every week, allowing affordable healing to occur— through a holistic fair followed by a magical sound healing bath meditation that is healing people at large. I have inspired others to start their own groups and gatherings. So, remember, never give up! Do what you love, and the money will follow because when you are doing a service to the Universe, and to God's children, the Universe will provide back. That's why I am also a manifestor; magic always comes my way. Creating my manifesting postcard for *Postcards to the Universe* only solidifies that.

I have helped transform my clients though a multi-sensory journey that recharges and activates every cell in the body. I do it both in person and remotely. I have been featured in numerous local and national TV, radio, and print media, including *People* magazine, *The Montel Williams Show*, and ABC's *20/20*. I have created a healing community in South Florida. I am blessed and grateful, and I am here for anyone who may need me. The best way to find me is at sherikaplan.com.

Sheri Kaplan

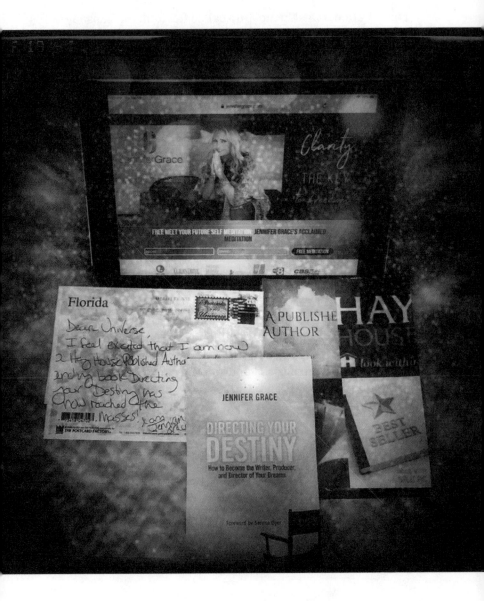

"Dear universe, forever grateful for your abundance."

—Jennifer

Directing My Destiny

On 1/11/11 I sent a postcard to the Universe about my book, *Directing Your Destiny*, requesting it to be picked up by Hay House Publishing, which was a pretty bold request, because I had not written a single word of the book that had been living in my head. Yet, that written declaration sparked my action to finally stop thinking and talking about writing a book and actually do it!

I remember after sending it, sitting down and doing some research; I didn't even know how many words a self-help book needed to be. I quickly found out it needed to be fifty thousand words. That very day, I wrote my heart out for one hour straight. I was able to write five hundred words in an hour. Then I did the math: if I wrote for one hour a day, in only four months I would have a fifty-thousand-word manuscript. Now the trick was finding the time. With ten private clients, group coaching classes, and an eleven-year-old son to tend to, I didn't think I could find the time. Yet, I knew I had to create the time. I decided that I would wake up early, write before my son got up and the workday started—from 5:30–6:30 a.m. I was excited for this writing journey to begin.

But that next morning, when the alarm went off at 5:30 a.m., guess what I did? That's right. I hit the snooze button eleven times. I realized I would need to outwit the self-saboteur that lives inside of us all. So, for the next day, instead of an alarm, I set an event. When it went off the next morning, again at 5:30 a.m., I looked at the event, and it said this: "Jen, do you want it or not?" That phrase got me up that next day and every day for the next four months.

When I was done with my manuscript, I very excitedly called my ex-husband Joe and told him I had finished my first book, and offhandedly said, "And now, I just need to get it into the hands of Wayne Dyer."

FREE MEET YOUR FUTURE SELF MEDITATION · JENNIFER GRACE'S ACCLAIMED
MEDITATION

FREE MEDITATION

Clarity

Grace

ida

Postcards
Universe

A PUBLISHE
AUTHOR

HA
HOU

Universe,
l excited that I am now
House Published Autho
book Directing
Destiny has
reached the
Masses!

JENNIFER GRACE

DIRECTING YOUR
DESTINY

How to Become the Writer, Producer,
and Director of Your Dreams

Foreword by

"Wayne Dyer? " he said.

"Yes, he is one of the biggest authors at Hay House, and that is the publishing company I want to be with."

Then he said, "You are not going to believe this, Jen. We are going to see Wayne Dyer next week, come with us!"

He further explained that his new wife had grown up next door to the Dyers, and that she was very close with them. Wayne was in town from Maui to help his daughter Serena with a charity event. The next thing you know I was standing in front of Wayne Dyer, telling him I had written my first book on manifestation, and since he was the Godfather of manifestation, I asked him if he would he be open to reading my book and giving me feedback. Yes, this was the Universe giving me my gift.

Not only did he say, "yes," he also gave me his home address in Maui to send it to him directly. After reading it, he informed that there was a contest Hay House was doing out in California, and one person would win a book deal with them. He felt my message was strong, and that I had a great shot of winning.

I followed his advice...and I won!

Not only did they give me the first prize, a book deal, but they also gave me the second prize, a radio show! My spot was sandwiched in between Wayne Dyer and Esther Hicks.

My book was published at Hay House, and I got my message to the masses.

I will be forever grateful to Melisa and *Postcards to The Universe* for being the catalyst for having one of my greatest dreams come true.

"Dear Universe, I feel excited that I am now a Hay House published author and my book Directing Your Destiny *has now reached the masses! Forever grateful for your abundance."*

Jennifer Grace

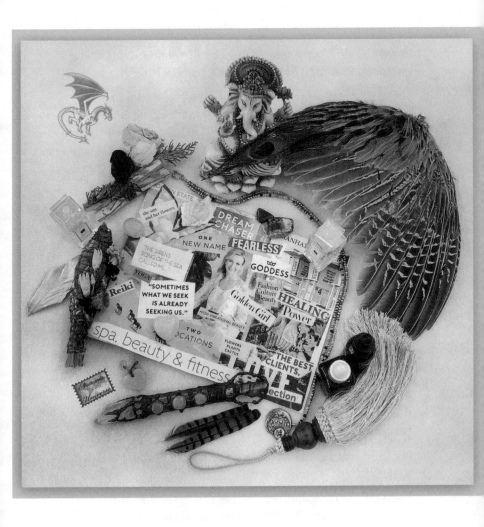

"Sometimes we seek what is already seeking us."

—Michelle

California Dreaming

I was lost in my twenties, getting by while bartending and waiting tables in very short and delightfully tacky orange shorts! Ten years passed in that position. I was one heck of a chicken wing connoisseur and quickly becoming one of the *older girls* on the job, at the ripe age of twenty-five. I wanted more from life, but without a proper college education I felt I'd never get ahead. There was also a very charming boy, whose parents didn't think I was good enough to marry (or so I thought at the time). So, I enrolled in junior college to get a degree to make me worthy of marriage and pursued nursing, because I come from a lineage of caretakers. I naturally thought it was my calling. I barely finished the first two years, and earned an associate degree in health science—nursing was actually not my cup of tea. I soon experienced my first real heartbreak, the kind that knocks the wind out of you and makes you question if you will ever recover. I was descending and spiraling downward fast.

Luckily, a good friend invited me to stay with her in Newport Beach, California where I could get my head back on straight. Into my car, and off to California I went. It was a five-day, cross-country adventure, with my ride-or-die by my side, my good friend and dear angel, Kimmy. Looking back, I know she was in my life as some type of protector, I always felt safe with her, even at my weakest and most reckless times. Nine months passed by, and I was really fitting in and adapting to the Southern California lifestyle. I found my home—it was the place of yoga, wheatgrass, farmers markets, surfers, artists, and wind. The west coast was where I wanted to stay for life. Then, the boy called. He wanted me back and promised to marry me. I would do anything to have him, so I packed it up and went back home to Florida. What a mistake! If I could go back and tell my

twenty-five-year-old self anything today, it would be: "You are worthy, you are enough. Love yourself first."

There I was, back in Florida, heartbroken, sad, and feeling hopeless, living in my mother's condo with no real plan. She basically told me to pick a career, get on with my life, or get out of her house. I literally got out the Yellow Pages and found something of interest, The Florida College of Natural Health, not exactly nursing, but it was something. I was determined not to go back to waiting tables. Two months into my year-long program, I found out my mother had breast cancer. *That's it*, I thought, I now know why I was here again in Florida—not because of the boy, but because I needed to take care of my mother through this very difficult time. It was a very long and stressful year, and as soon as she was in remission and healthy again, I was determined to go back to California. The land and energy I missed so much! I had a fire in me to escape the sadness Florida brought me, and to make it *big* in the golden state. I knew I had to work hard and visualize myself there again. Soon after, a job opportunity presented itself after working as a massage therapist in a boutique hotel spa in South Beach Miami, to transfer to Los Angeles! Broke, but ambitious, I sold my belongings, and headed out west again, deciding to open my own spa one day, make a name for myself, and never look back. Nobody believed me. I was told I was a dreamer, and I'd never be more than just a cocktail waitress.

It was now 2003, I had been in California for two years, working on celebrities, models, and politicians. I worked amongst the most elite clientele and was making my way as a top therapist in Hollywood. I had even worked solely for one celebrity and was on location for six months while filming. In this time period, I had my daughter, got married, and then divorced. Plus, I added another modality/certification under my belt. I was now a dual-licensed therapist, with my main focus being skincare. I worked in spa management for several years in fitness clubs, working

on building talent, training them on modalities, writing protocols, driving sales, and building a clientele in the South Bay. I was working so hard to make someone else very rich. I was getting frustrated...after all, it was my gift of healing that had people coming back, and was helping to hit those sales goals. I knew this wasn't it for me.

I needed to stay on my path of following my dream. It wasn't until years later, in 2012, that I left my corporate spa management position to really pursue my dream—opening my own spa. *Inner Glimmer Skincare and Wellness Studio* was established in 2012, in the heart of Manhattan Beach, California. Once I took the leap to become a sole proprietor, I knew I was living my purpose: sharing my gifts of healing and passion for wellness, health, and beauty. Since then, I have been featured in numerous magazines, and served as an expert for *Charlotte's Book*—a modern resource for the best in the beauty industry. I have a two-month waitlist for my services, and I couldn't be more grateful and blessed. I am able to support myself and my daughter, and live in a little beach house by the sea with an ocean view. I even bought myself a Mercedes-Benz. It certainly hasn't always been easy—being a self-made business owner and boss-lady—but every challenge I've faced has only made me stronger, wiser, and a better human. I believe in *Postcards to the Universe's* magic. I believe in the Law of Attraction. I believe in myself, and I count my blessings every day. I plan to have a second location soon, and manifest much more. Who knows...maybe I'll even fall in love again. I'm working on my heart chakra. Anything is possible!

Michelle Steele

"I'm inspired."

—Johnny

Embracing Italy

For years, I have wanted to get dual citizenship. I am Italian-American, but wanted the ability to also be an Italian citizen. I am lucky, because as a second-generation Italian, here in America, I was eligible to also become an Italian citizen, according to the citizenship laws in Italy. I went through the very long process of gathering all my family's documents, proving that my grandparents were born in Italy and migrated to the United States, where they had given birth to my parents. It took me years of hunting down documents from other states, getting official seals from state offices. They were very specific on what they needed, and the process was expensive and timely. But I knew if I wanted it badly enough, it could happen. When I finally got everything in order, I had to make an appointment with the Italian Consulate in Miami. The appointment was for a year-and-a-half from the date I made it. It seemed everything in this process would be a wait.

Fast forward to the date of my appointment, I was very nervous because part of the process was me giving over the original documents, which I was told I would never get back. I had, of course, made copies, but if something went wrong, those originals would be lost to me forever. I had joined an online forum with other people going through the same process as me, and from what I was reading, making it happen in Miami was particularly difficult. The wait was long, compared to some of the other Italian Consulates. Many people were waiting years for their appointments, let alone getting actual citizenship. But I had no choice as to which consulate to go to; you had to go to the one assigned to your address. Since my address was in Fort Lauderdale, the Miami consulate was my only choice.

Everything went great, and I had all the papers that were required. I was told that I was eligible. I was beyond excited. They told me to expect all my official documents to come

in the mail in about six months, and then I could go and get my official Italian passport. Six months came and went... yet, *nothing*. Being on the forum, I was seeing others who also received their "yes," but were waiting for over a year for their paperwork. One year passed and nothing, then another six months, and still nothing. I was seeing some people were on two, even three years, and still hadn't receive their official citizenship documentation. I was feeling very deflated. There was nothing I could do. There was no phone number to speak to anyone, and emails were not being responded to.

At this same time, I was learning Italian, and I had hired a tutor. I also had joined an app where you could talk to other people from different countries and each helps the other with learning their respective native language. I had connected with a few people from Italy who wanted to speak English, as I wanted to practice my Italian. I had become very good friends with one woman in particular. Her name is Maria. We would chat on a regular basis, and she wanted to introduce me to her best friend Regina. I was single, and so was Regina, who was Italian, but happened to be living in Tenerife in the Canary Islands. She somehow thought we would really connect. I had been wanting to do some traveling and was itching to get over to Europe. Maria introduced me to Regina, and we started talking on WhatsApp, which led to daily conversations. This led to Skype sessions a few times a week. We decided to meet in Portugal, and then I would follow her back to Tenerife for a week.

I had no expectations. I went into this completely open to just making another friend, and having someone to travel with. Being a single man with no kids, most of my other friends don't have the freedom to travel like I do. So, this was really an unexpected adventure. We completely hit it off and had such a great time together. I left to come home, and we kept in contact. That was last summer, and every

day since the first day we connected, we have grown closer and closer. We have become so close in fact, she is coming over here, and we are getting married this spring.

This is our first marriage for both of us. It is incredible how I met someone who lived on the other side of the world. She is a lot like me in many ways, and her friend Maria says that she knew we would be perfect for each other.

I have known Melisa for a long time. We grew up together, and she would always talk about her postcard project. She would tell me to stop worrying, that if being an Italian citizen was something I really wanted, that it would happen. I sent her some postcards from my trip, which she included in this postcard. She would say all the time, "Stop worrying. It is on its way." She knew how badly I wanted it. She would tell me to let it go, and that my papers would arrive.

But here is the crazy thing…my papers still haven't arrived, but the woman I am marrying, whom I met so unexpectedly, is Italian, so it really doesn't matter anymore. I got what I asked for, plus so much more.

You were right, Melisa—as usual.

Johnny B.

Postscript

Living in Gratitude

"Our deepest fear is not that we are inadequate.
Our deepest fear is that we are powerful beyond measure.
It is our light, not our darkness that most frightens us.

We ask ourselves
Who am I to be brilliant, gorgeous, talented, fabulous?
Actually, who are you not to be? You are a child of God.

Your playing small does not serve the world.
There's nothing enlightened about shrinking
So that other people won't feel insecure around you.

We are all meant to shine, as children do.
We were born to make manifest
The glory of God that is within us.

It's not just in some of us;
It's in everyone.

And as we let our own light shine,
We unconsciously give other people
permission to do the same.
As we're liberated from our own fear,
Our presence automatically
liberates others."

~ Marianne Williamson

One of the greatest and most persuasive ways to manifest what you want is by living in gratitude. I have created *Manifesting through Gratitude*, an online course, and it is a thirty-day commitment. It is very powerful. I will share a brief synopsis, and an exercise that you can do at any time. The course is very detailed, and it's broken down into life themes. But basically, every day for a month, find one thing that you are grateful for in the one area of your life that you want to manifest something new or shift the energy. I ask people to take a photo of what they discover as they are going through their day. So, let's say for example, the area you want to shift is love. You want a romantic relationship; however, you aren't in a relationship at the moment. You have created your postcard around finding a partner. Now, you must get into that space of gratitude for receiving that. Every day, find one thing that makes you grateful for the love that is already in your life. You already have so much love around you, notice it, and be grateful for it.

You must also feel worthy of love. That is probably more important than anything else. If you do not love yourself, you cannot expect to bring in the kind of love you desire. This is where gratitude comes in. By shifting our focus to gratitude, we build day-to-day on the blessings we already have. By focusing on those things, we see how many gifts we already possess, and we see how much we are loved by the Universe, and how worthy we are. Doing this every day for a month, and focusing on that area in our lives we are grateful for, literally changes our brains. When we start to make a habit of finding the things in our lives we are grateful for, we train our brains to search these things out! Learn how to make this a healthy habit in your life. The more you focus on finding things or situations that you are grateful for, the more you will want to do it. I have heard that twenty-one days is the magic number in creating a healthy habit for it to stick. How about using this for gratitude? I promise you it will enrich your life enormously.

As you are noticing that thing or experience in your gratitude journey, I want you to take a photograph with your phone. Everyone has their phone with them almost everywhere they go. Use it for manifesting. In a month's time, you will have a visual gratitude journal. It can be stored in a private app on your phone. You can print out the pictures, and post them in a notebook where you can write what you are grateful for. By the end of the month, you'll have created a physical, visual journal full of images of what you want. Can you imagine how powerful that would be? You are committed to your goals and desires. The Universe will respond to that energy and set up experiences, opportunities, and synchronicities to give you what you want.

Being in gratitude is one of the most wonderful feelings in the world. Being grateful makes us happier, healthier, and people are attracted to grateful people. People like being around other grateful people. It adds to our health. Grateful people sleep better. Being grateful makes us more compassionate and loving. Gratitude creates better relationships with everyone in our lives. We bounce back from stressors more quickly when we are grateful. The more grateful we are, the more gifts we receive to be grateful for. Grateful people appear more attractive, and are a joy to be around. Living in gratitude is like taking a daily multivitamin; it is great for your overall well-being. Being in gratitude can boost our careers, and we are more likely to get hired for a job. Those living with gratitude are more optimistic. Being thankful can increase our self-esteem, and make us less self-centered. Grateful people are interested in others. Gratitude makes us want to share our blessing with others. Living in appreciation will increase our energy, and possibly even our life span. Gratitude is contagious and it expands. Living your life in gratitude feels really, really good.

Studies have been done at the Institute of HeartMath by leaders in fields such as cardiology, psychology, biofeedback, psychics, and biophysics, just to name a few, on how gratitude can literally change our heart. When gratitude, love and appreciation are felt, our hearts give off a different beat. Which causes specific signals being sent to our brain. This expands our magnetic field outward and can impact, and be felt by, others around us. This evidence suggests that we are connected to every person on our planet and to beautiful Earth herself. The research goes much deeper, suggesting that we can change the world by changing human consciousness. It is pretty amazing how much influence we actually have by just becoming more grateful in our life.

Out of every tip and technique I offer, I believe gratitude is the most compelling tool we can use in manifesting, and manifesting quickly. You cannot fake gratitude; it must be genuine. That is why I recommend doing the visual gratitude journal for at least thirty days. It gets into your psyche and shifts your energy into thankfulness.

The Universe loves us, and wants us to have what we desire. Too many of us focus on what we don't have, and that is the energy that expands. The Universe only responds to our energy, so if lack is where we are, it shows up as more lack. But, if you can shift into abundance and gratitude, the Universe brings you more of that. We are co-creators with the Universe in what happens in our lives. We have so much more power than we realize.

When you believe in magic, magical things happen.

Postcard Contributors

1. Terri Lopez—Author, Dancer, Actress

2. Eliza—Teacher, Artist, Wife, and Mother

3. Diana Silva—Creator and Author of, *Molé Mama, A Memoir of Love, Cooking and Loss*, Radio Host, and Entrepreneur

4. Dana DellaCamera—Singer, Songwriter, Artist, Filmmaker, and Life Coach

5. Laura Hudson—Creator of *Me Too No More* movement and Author of *The Secret About Domestic Violence They Don't Want You to Know*

6. Elizabeth Lindsay—Creator of *Angel with an Edge*, Artist, Radio Host, Clairvoyant, Medium

7. Christine Millan—Artist, Creator of *Great Paint Parties*, Mother

8. Jake Cordero—Artist, Entrepreneur

9. Jenny Diebold—Creator of *The Jenny Guides*, Mother, and Entrepreneur

10. Seth Barker—Creator of *Today is a Great Day* movement

11. Barry Gross—Artist

12. Kim Windell—Police Officer, Wife, and Mother

13. Teresa—Founder and President of Rainbow Guardian Inc., A non-profit charity that serves the developmentally disabled.

14. Niki Lopez—Artist, Filmmaker, Entrepreneur, and Creator of What's Your Elephant movement.

15. Mary Pohlmann—Artist and Activist

16. Robby Allen—Medical Aesthetician, Actor, and Artist

17. Eliane Harvey—Artist, Art Curator, Wife, and Mother

18. Jordana Foster—Motivational Speaker, Coach, Radio Host, Creator of Ready Set Go Beyond

19. Marie Donze—Artist, Curator, Workshop Facilitator

20. Carolyn Flynn—Author, Editor, Contributor

21. Dori Liotta—Co-Founder of Love Sami Organization, a non-profit charity that helps families touched by suicide

22. Rick McCawley—Photographer, World Traveler, Teacher, and Father

23. Samantha Caprio-Negret—Author of *Rainbow Crystal*, Writer, Wife, and Mother

24. Angelique Metroyer—Writer, Activist, Dreamer

25. C—Teacher, Attorney

26. Sheri Kaplan—Energy Healer, Intuitive, Transformational Coach, Motivational Speaker, and Author

27. Jennifer Grace—Mother, Author of *Directing Your Destiny*, Speaker, Spoken Word Artist, and Leader

28. Michelle Steele—Mother, Skincare Specialist, Wellness Expert, and Owner of Inner Glimmer Skincare Studio

29. Johnny B—Narrator

Acknowledgments

I cannot begin to express my gratitude in being able to see my book manifest into reality. The support and encouragement of my family and friends has been my beacon of light on this amazing journey. When I felt overwhelmed and exhausted, I had my team of cheerleaders rallying around me to bring me up and keep me on track.

I want to personally thank my parents, Teresa and Phil, and sister Samantha for their unwavering faith in me and support of my living my dreams. I wouldn't know what to do without them. I love you! And my sister Toni who has opened up our families' lives in amazing ways. My dear friends who always knew I could do it and would constantly tell me to keep going, and my mentors, coaches, and guides who helped hold my vision. And my eternal thanks to the Universe who loves me and always has my back.

Of course this book couldn't exist without the contribution of the amazing manifestors who submitted their postcards and stories to me. Thank you! I wish each of you continued success in living your dreams—Terri, Eliza, Diana, Dana, Laura, Elizabeth, Christine, Jake, Jenny, Seth, Barry, Kim, Teresa, Niki, Mary, Robby, Eliane, Jordana, Marie, Carolyn, Dori, Rick, Samantha, Angelique, C, Sheri, Jennifer, Michelle, and Johnny.

I want to thank the very talented Carolyn Flynn for her amazing editing skills of my book proposal and helping me find and get published with Mango Publishing. I also want to thank the team at Mango for their incredible support and being so helpful and patient with me during this exciting adventure.

To the readers—thank you for picking up my book and contributing to the energy of my movement. I hope you find inspiration here in the stories, that it prompts you to join me on this global movement for manifestation, and that it contributes to your amazing manifesting journey.

I am eternally grateful and sending my love out to the Universe!

Melisa

About the Author

Melisa Caprio, author, photographer, radio host, and creator of *Postcards to the Universe™ A Global Movement for Manifestation*, is inviting people from around the world to participate in this movement by using photography, art, personal wishes and desires, and sending them out to the Universe via a postcard. Her inspiration comes from a desire to have a forum where people come together in creative ways for global change. She is currently giving workshops on photography, art, transformation, and manifestation. She guides her clients on how to create a unique postcard for added effect on the power of creative intention. Her site www.postcardstotheuniverse.com is interactive and features the postcards that she receives on her blog.

Caprio has her own weekly radio show titled *Postcards to the Universe* with Melisa on 12Radio.com where she interviews spiritual trailblazers; she has turned this show into a popular podcast. She is the author and publisher of The Artist and the King, a true story, and Creative, Fun and Easy Tips on How to Photograph Children and Animals (Amazon). She has been featured in ROAR: Fierce Feminine Rising Magazine, and Voyage VIA Miami Magazine. She is a regular contributor on Thrive Global. Caprio has been featured numerous times in the local newspaper Sun Sentinel: Broward and Palm Beach News on her work and also exhibits her photography work on a regular basis in fine art galleries in South Florida. Learn more by visiting www.melisacaprio.com.

Mango Publishing, established in 2014, publishes an eclectic list of books by diverse authors—both new and established voices—on topics ranging from business, personal growth, women's empowerment, LGBTQ studies, health, and spirituality to history, popular culture, time management, decluttering, lifestyle, mental wellness, aging, and sustainable living. We were recently named 2019's #1 fastest growing independent publisher by *Publishers Weekly*. Our success is driven by our main goal, which is to publish high quality books that will entertain readers as well as make a positive difference in their lives.

Our readers are our most important resource; we value your input, suggestions, and ideas. We'd love to hear from you—after all, we are publishing books for you!

Please stay in touch with us and follow us at:

Facebook: Mango Publishing

Twitter: @MangoPublishing

Instagram: @MangoPublishing

LinkedIn: Mango Publishing

Pinterest: Mango Publishing

Sign up for our newsletter at www.mango.bz and receive a free book!

Join us on Mango's journey to reinvent publishing, one book at a time.